CELEBRATING THE FAMILIAR

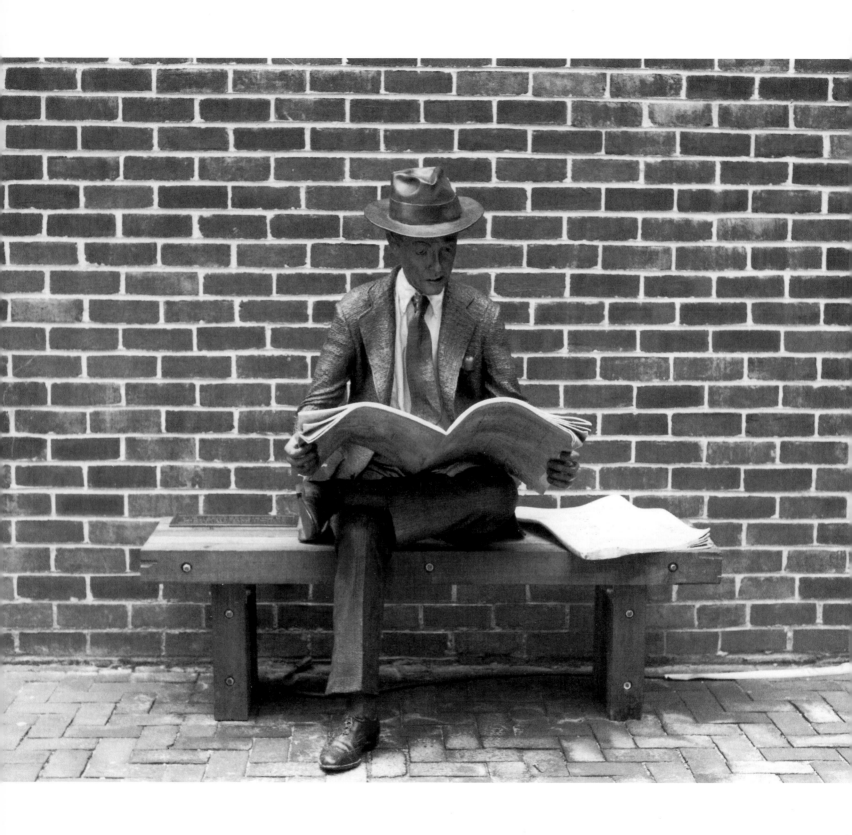

CELEBRATING THE FAMILIAR

THE SCULPTURE OF
J. SEWARD JOHNSON, JR.

A Tenth Avenue Book

ALFRED VAN DER MARCK EDITIONS • NEW YORK

Frontispiece: **THE NEWSPAPER READER**
Contents page: **CATCHING UP**

TENTH AVENUE EDITIONS, INC.
625 Broadway, New York, NY 10012
Managing Editor: Clive Giboire
Photographic Consultant: Richard Baron
Associate Art Director: Elizabeth Byrne

ALFRED VAN DER MARCK EDITIONS
1133 Broadway, Suite 1301
New York, New York 10010-7902

Library of Congress Cataloging-in-Publication Data
Johnson, J. Seward, 1930-
 Celebrating the familiar
1. Johnson, J. Seward, 1930– —Catalogs.
2. Bronze sculpture, American—Catalogs. 3. Bronze
sculpture—20th century—United States—Catalogs.
4. Humans in art—Catalogs. I. Title.
NB237.J54A4 1987 730'.92'4 87-50235
ISBN 0-912383-57-7
ISBN 0-912383-56-9 (pbk.)

Separations by the International Scanner Corporation of America

Printing and binding by H. Stürtz, Würzburg, West Germany

First Printing 1987

To my wife, who sacrificed years of developing her own profession and other personal realizations so that I could commit myself to producing the sculpture contents that appear in this book.

ACKNOWLEDGEMENTS

We thank Paula Stoeke, curator for Seward Johnson and Director, Sculpture Placement Limited, for generously sharing her knowledge and understanding of the sculptures; Nancy Sausser of Sculpture Placement for her painstaking attention to our many demands; Nancy Galeota-Wozny, Lucinda Leach, and Susan Perry, staff members of Sculpture Placement Limited, for a wide spectrum of assistance; Dona Warner, director of production, the Johnson Atelier; Shirley Beers for her cheerful support; Sandra Hardy for editorial solutions; and Rose Hass for her advice and encouragement. Above all we want to thank Seward Johnson who put aside a great deal of time from his very busy schedule to assist us in making this book as accurate and beautiful as possible.

Tenth Avenue Editions gratefully acknowledges David Cutler's assistance.

Finally, our thanks go to the following photographers:
(Black-and-white photographs by page number)
Richard Baron, viii, 46, 122, 123, 124, 125; Jim Barton, 26;
The Daily News, Lee Romero, 35; Clive Giboire, 43, 49; Donald Hamerman, 41, 45, 127 (center); Hofstra University, 40; Kelly & Massa, 7 (bottom), 32 (top right); Las Vegas News Bureau, 53, 54; New York Times Pictures, Neal Boenzi, 34; Newsday Photos, Bob Luckey, 29; Newsday Photos, 52; Safety Kleen Company, 47; Jeff Short, 27; Philip W. Smith, 38, 48; Paula Stoeke, 2 (top), 3, 4, 5, 6, 7 (top), 30, 31, 50; Sunnyvale Library, 55; The Washington Post, Larry Morris, 32 (top left).
(Color photographs by plate number)
Richard Baron, 1-11, 13-17, 27, 47-49, 67-68, 70-73, 84, 98-99, 110-114, 118-119, 124-126; Creative House, Kharen Hill, 56-57, 77-80; Clive Giboire, 64; Donald Hamerman, 87-88; Phil Hollenbeck, 85-86, 96; Ron Jautz, 117; Susi Moore, 50-51, 75, 91; Wojtek Naczas, 12, 108; Andrew Neuhart, 90; Tim Reif, 104; Philip W. Smith, 19-21, 24-26, 28-29, 31-35, 37, 39-41, 44-46, 55, 81-82, 97, 105-106, 109; Paula Stoeke, 18, 22-23, 38, 54, 58-59, 62-63, 65, 76, 83, 89, 100-103, 120-123; Faith Weil, 36.

J.S. Johnson, Jr.

CONTENTS

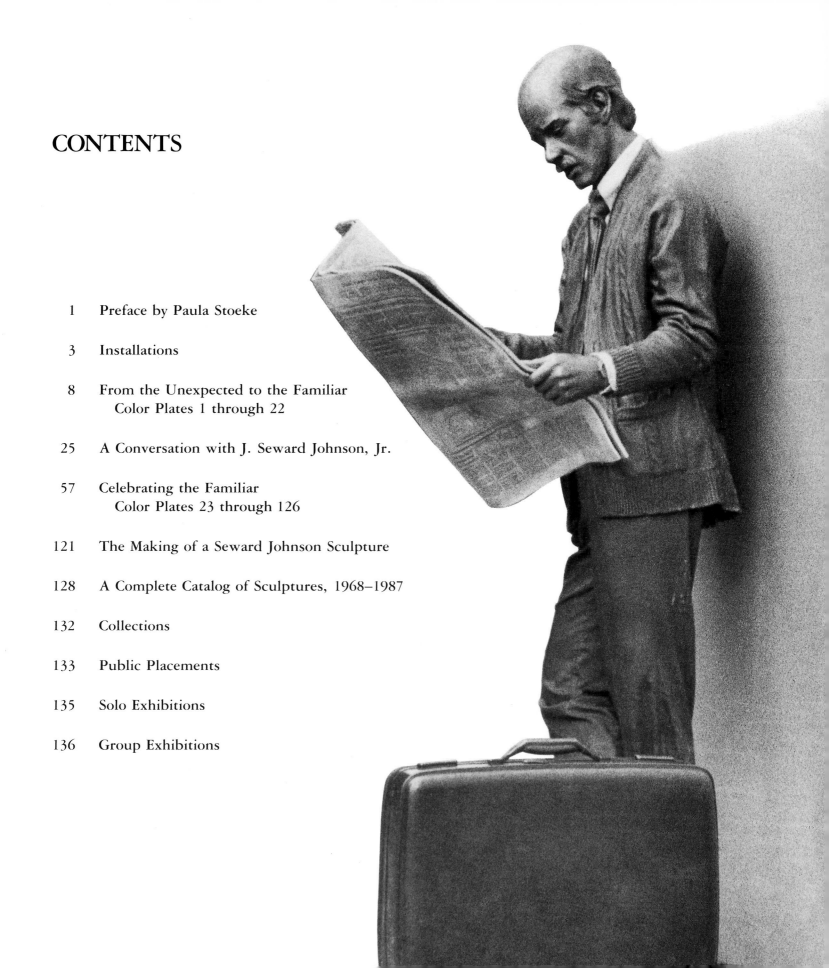

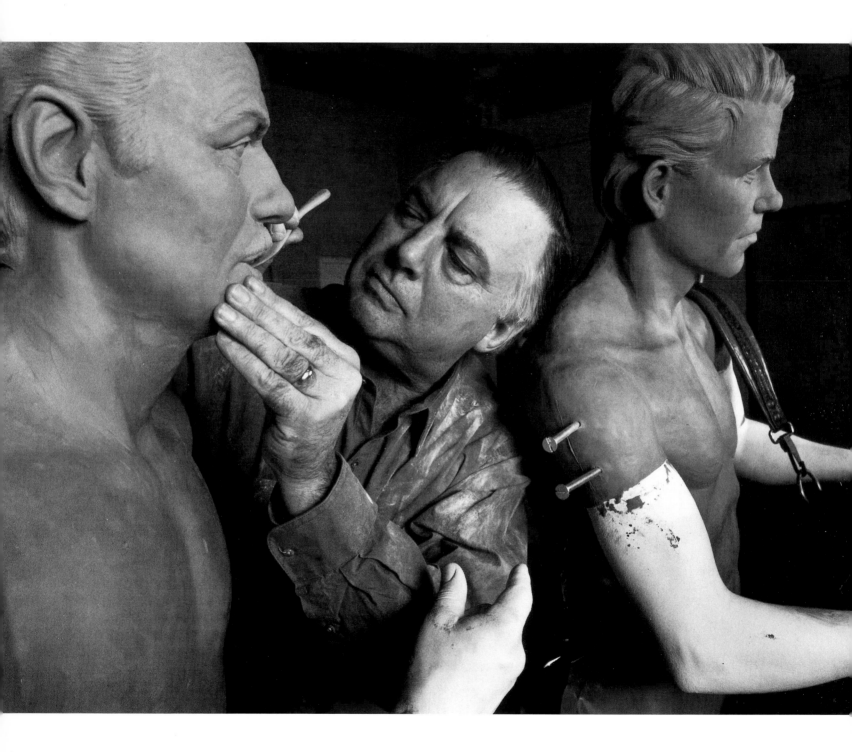

PREFACE
by Paula Stoeke

J. Seward Johnson, Jr.'s career as a sculptor had an auspicious beginning when, in 1968, his first work was awarded top honors in the Design in Steel competition. The piece was a stylized nude entitled *Stainless Girl*, but it was when he began producing life-size, meticulously sculpted, realistic bronze figures that the artist gained widespread public recognition.

Seward Johnson is a long studied observer of people. He spends time wandering through the streets and parks of urban New York City and rural New Jersey, taking note of conversational poses and dynamics. Back at his studio, these observations take on life as twelve-inch maquettes or gesture sketches in clay. Very often these small figures will inhabit the studio for weeks, forming playful random groupings. Their composition and relationships change as he develops the final form for a full-size sculpture. Once the concept is defined in the maquette, the piece is enlarged to human scale, and the foundry process begins.

It is fascinating to witness the technical production of the works in foundry. Stage to stage it is a riveting, energetic phenomenon combining the elements of extreme heat, molten bronze taking on the look of poured light, the din of hammers against metal and strong scents of wax and clay. The entire process from the creation of a foot-high clay sketch to a complete, fully detailed figure can take as long as two years.

Initially a painter, Seward Johnson began sculpting to further explore his interest in creating volume and shadow. The plane of a canvas was limited, and he was interested in the technical challenge of three dimensions. Frustrated by the failure of conventional foundries to offer a "hands on" approach to casting, he developed the Johnson Atelier.

This state-of-the-art casting facility, staffed by artists, allows Seward and other working sculptors to bend the rules, make

1

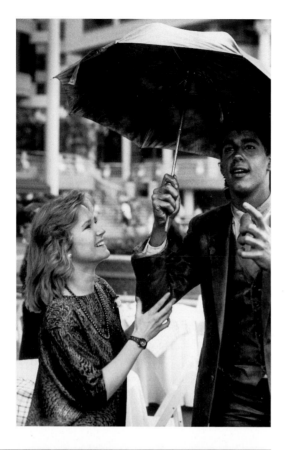

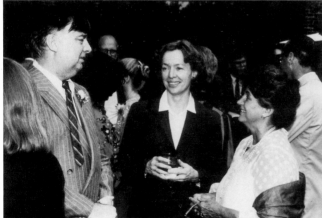

From left to right (above): J. Seward Johnson, Jr., his wife, Joyce, and Olga Hirshhorn. Paula Stoeke, (top) with model dressed as *Allow me*.

discoveries, and participate fully in the start to finish production of their art. A layman's engineer, Seward still enjoys tackling a challenging technical detail such as casting a delicate potato chip for *Courting,* or finessing the addition of electricity to an operating bronze lamp for *After Lunch.*

As Seward Johnson's curator for the past seven years, I have had the opportunity both to watch the creation of these images and to witness the ground swell of positive response to the sculpture. While preparing this book I received notes and anecdotes from across the country: there were stories of mistaken arrests by alarmed security officers and stories of gifts of the sculptures to commemorate affection, heroism, and a town's commitment to a more aesthetically satisfying landscape.

One account is of a wealthy Texas collector who purchased *Fishing* following an exhibition at a prominent hotel. When the hotel pond was dredged, and the bronze pail of fish which was part of the sculpture was discovered, the hotel staff surprised their guest at dinner by serving him the bronze bucket of trout for desert under a silver cover.

Exhibitions hosted by museums, developers, and townships have brought Seward Johnson's humor and spirit to locations as diverse as Rockefeller Center and the World Trade Center in New York City and the intimate Cheekwood Museum in Nashville. Voice of America, the United States Information Agency, and National Public Radio have introduced the artist's work to Europe, Asia, and the Soviet Union through broadcasts, exhibits of photos, and press reports.

In the autumn of 1987, a three-year traveling exhibition began in Munich, West Germany. Through the sponsorship of Lufthansa Airlines, the BMW Corporation, the Gulbenkian Foundation, and others, the bronzes will be viewed throughout Western Europe.

The most impressive moments of my association with this artist and his work have occurred as I watched anonymously from the sidelines while someone discovers a newly sited sculpture. Seward has been known to take a spot behind a nearby tree just to watch the first tentative touch grow familiar and become an intimate gesture between old friends. It is this personal connection, between the human spirit and his bronze counterpart, that is utterly convincing of the fact that these sculptures are alive today, and will outlast us all in their quiet, elegant communication.

SCULPTURE INSTALLATIONS

Installation of a J. Seward Johnson, Jr. sculpture exhibition always draws a crowd. Often the pieces arrive standing upright, or seated on their benches, wrapped mysteriously in blankets and firmly taped—like an intriguing cargo of mummies. The blankets are removed and each sculpture is exposed to the curious onlookers, then hoisted off the truck by crane—a spectacular sight. The installation crews frequently join passersby in taking playful poses with the sculptures.

The pieces are then either wheeled into place on dollies or securely buried below ground on an I-beam structure up to their feet. The sculptures are never raised on pedestals, but instead are placed amid ongoing activity, for a natural interaction with the landscape. When permanently sited, the figures appear to walk along a pathway, down a city sidewalk or to sit comfortably on a bench, just as any individual would.

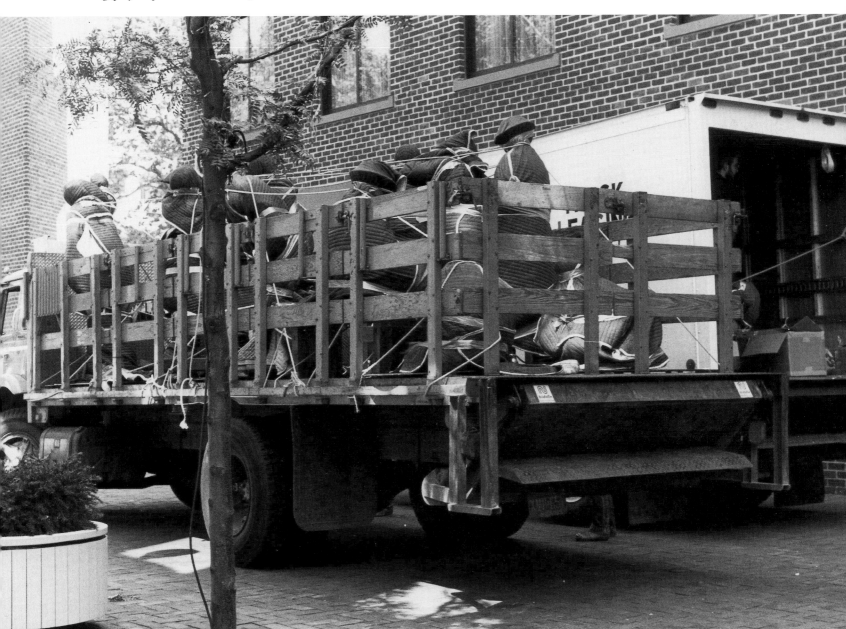

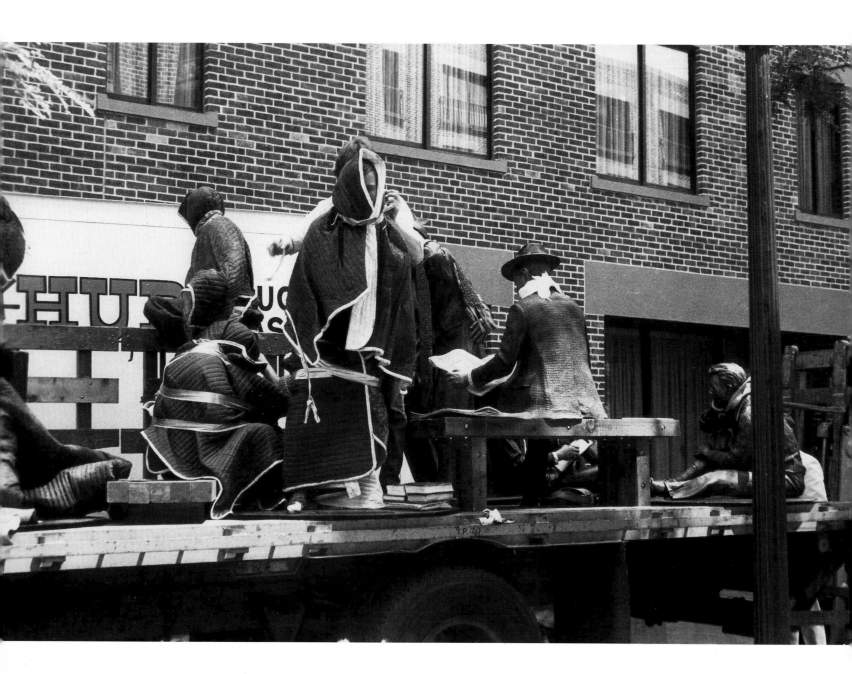

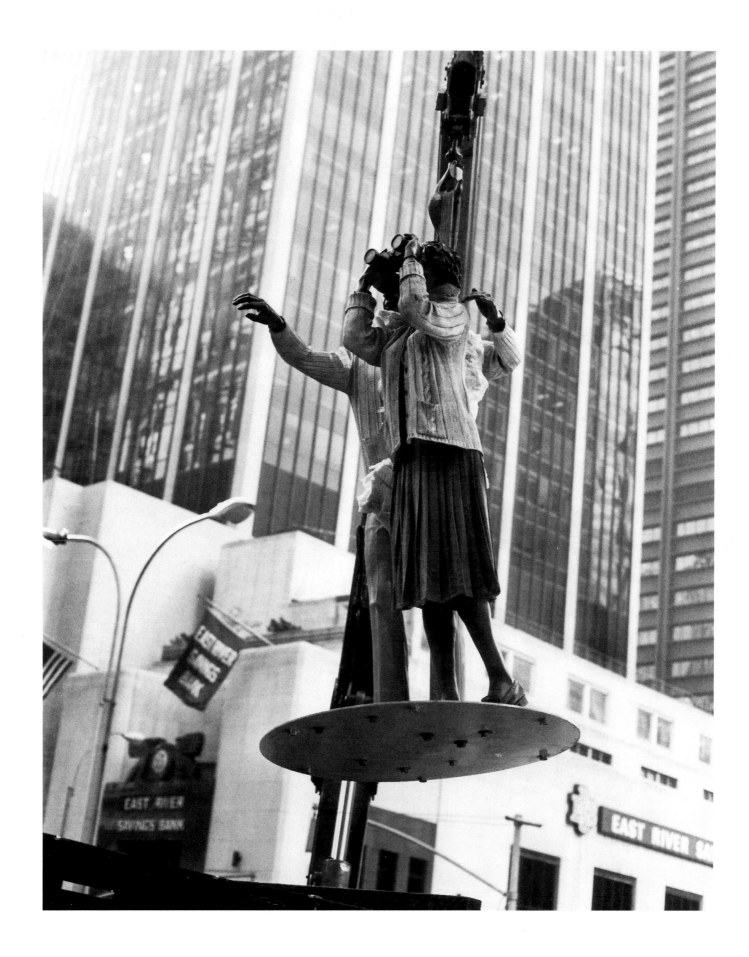

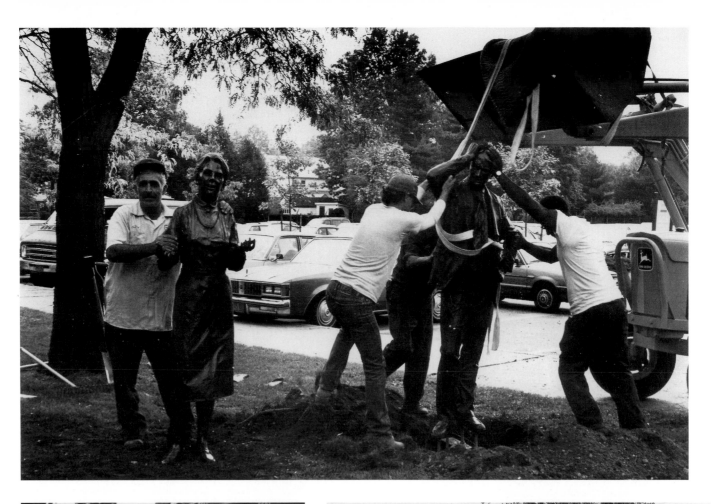

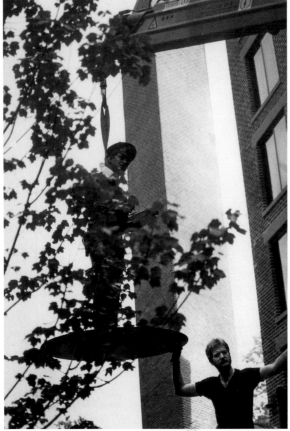

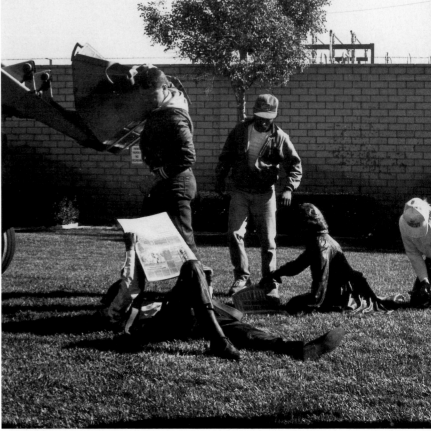

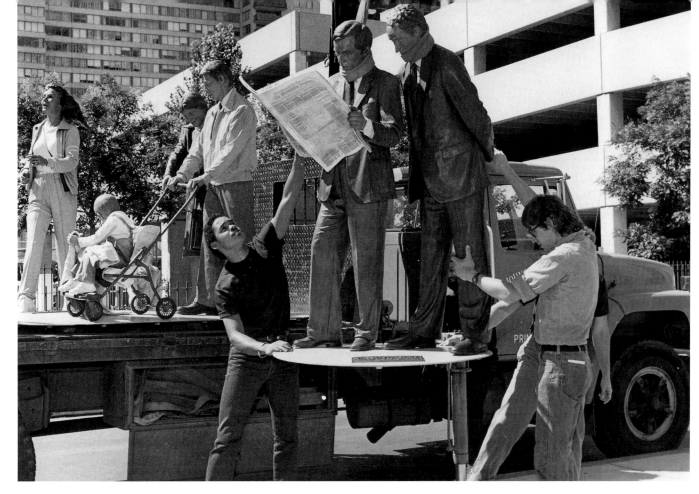

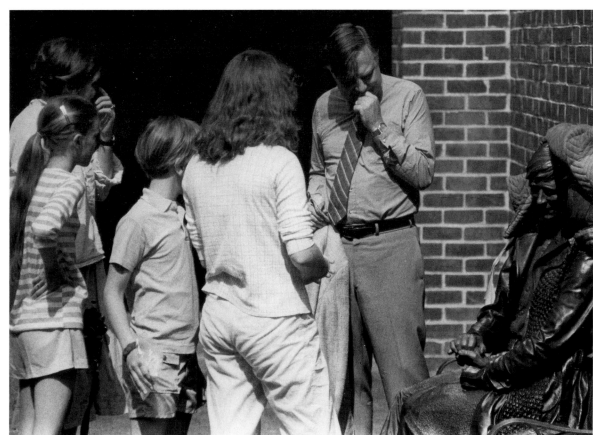

FROM THE UNEXPECTED
TO THE FAMILIAR

Color Plates 1 through 26

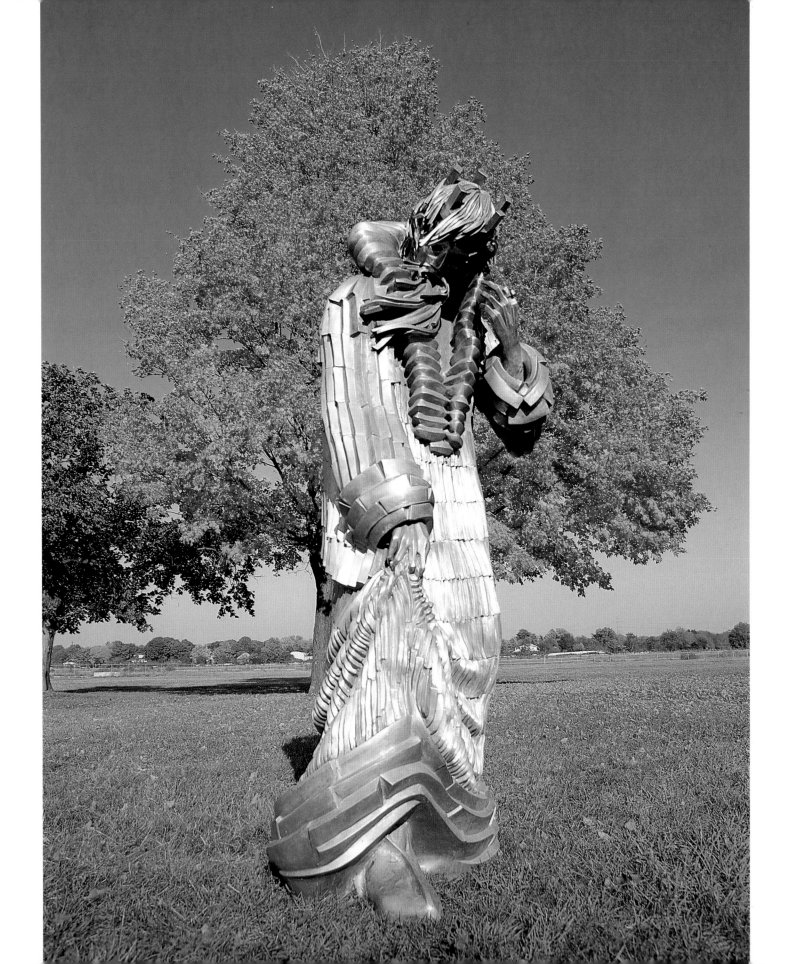

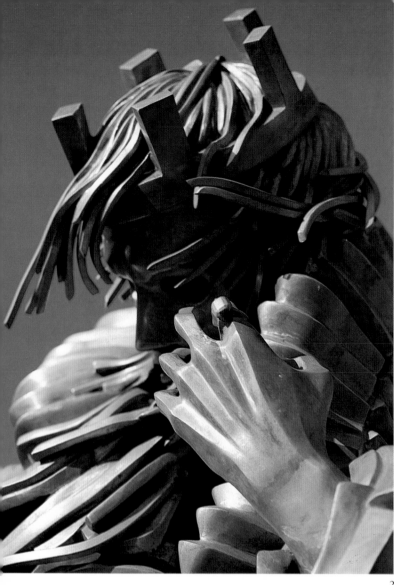

2

3

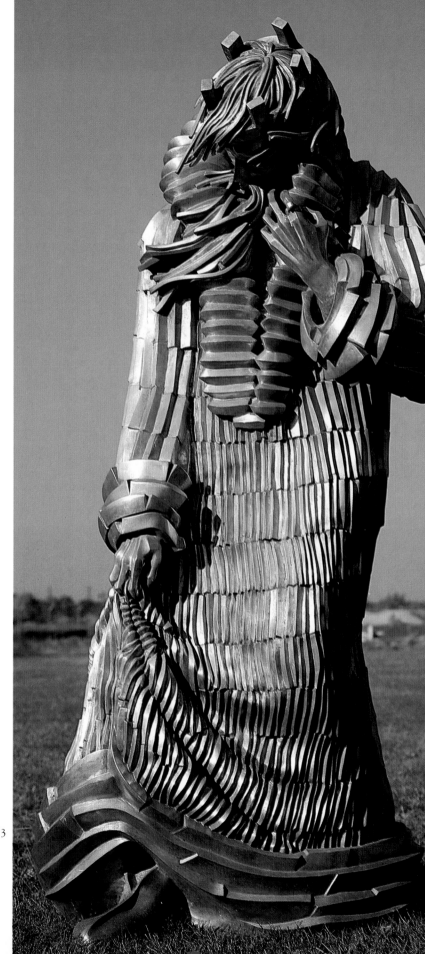

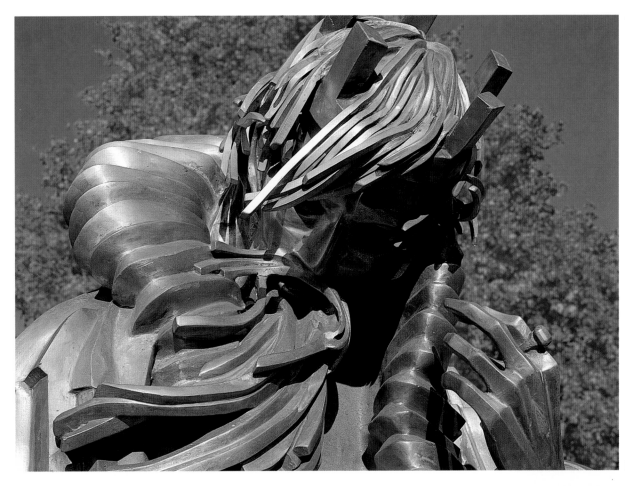

4

Plates 1 - 5. **KING LEAR**

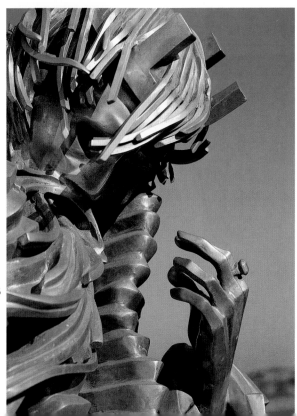

5

Plates 6 - 8. **FISHING**

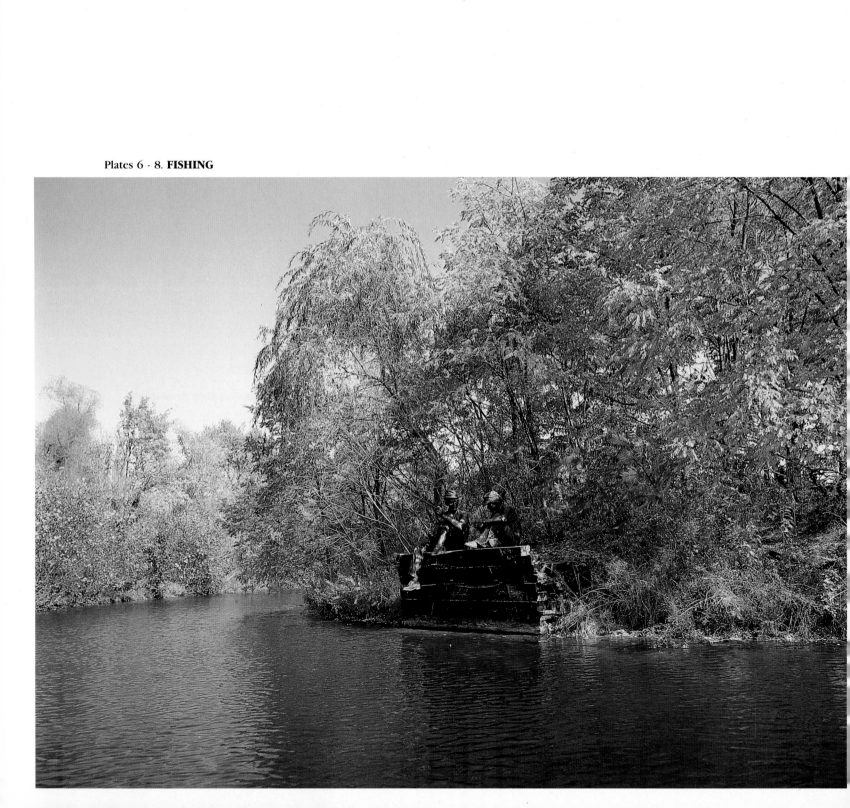

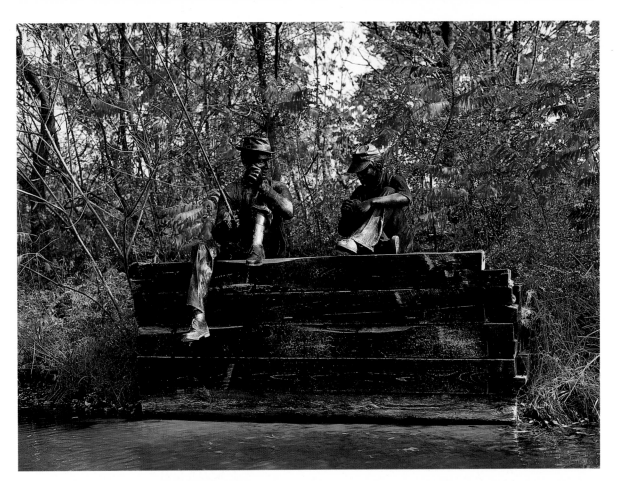

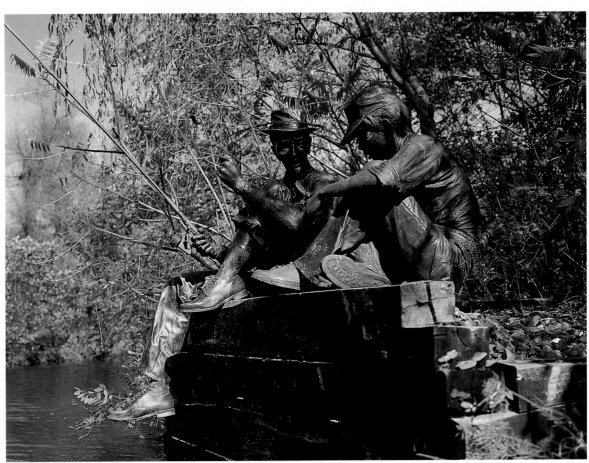

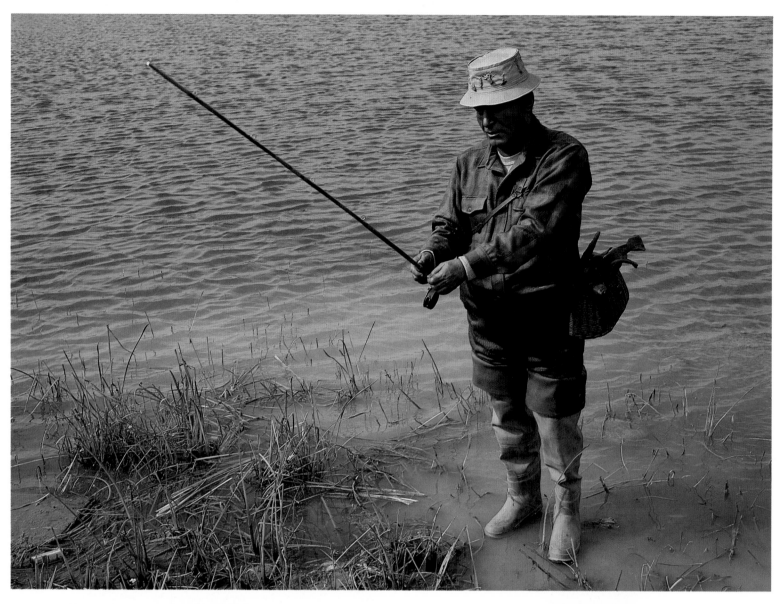

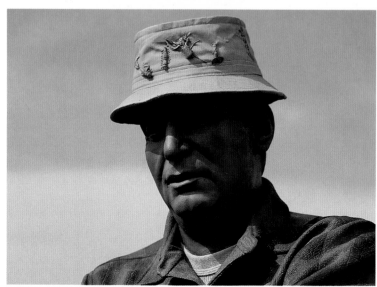

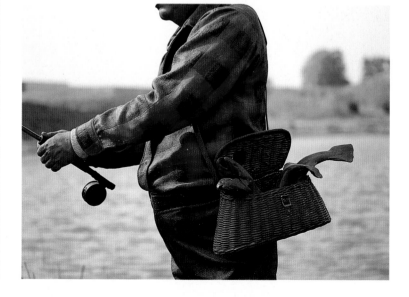

Plates 9 - 11. **MIDSTREAM**

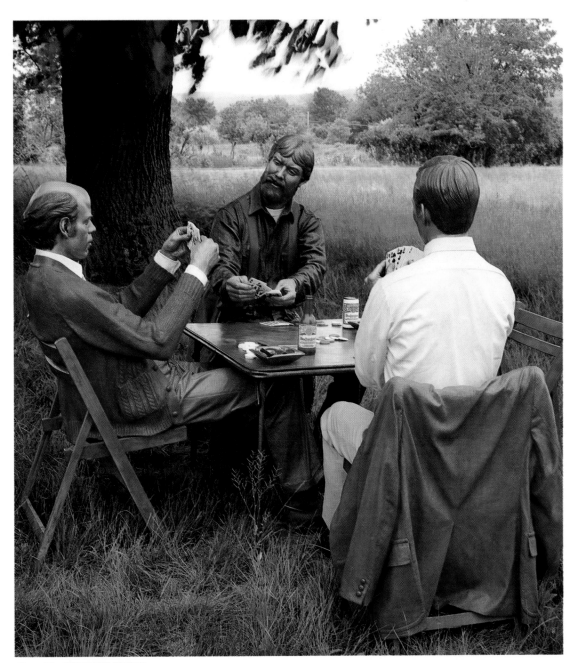

Plate 12. **FOURTH HAND**

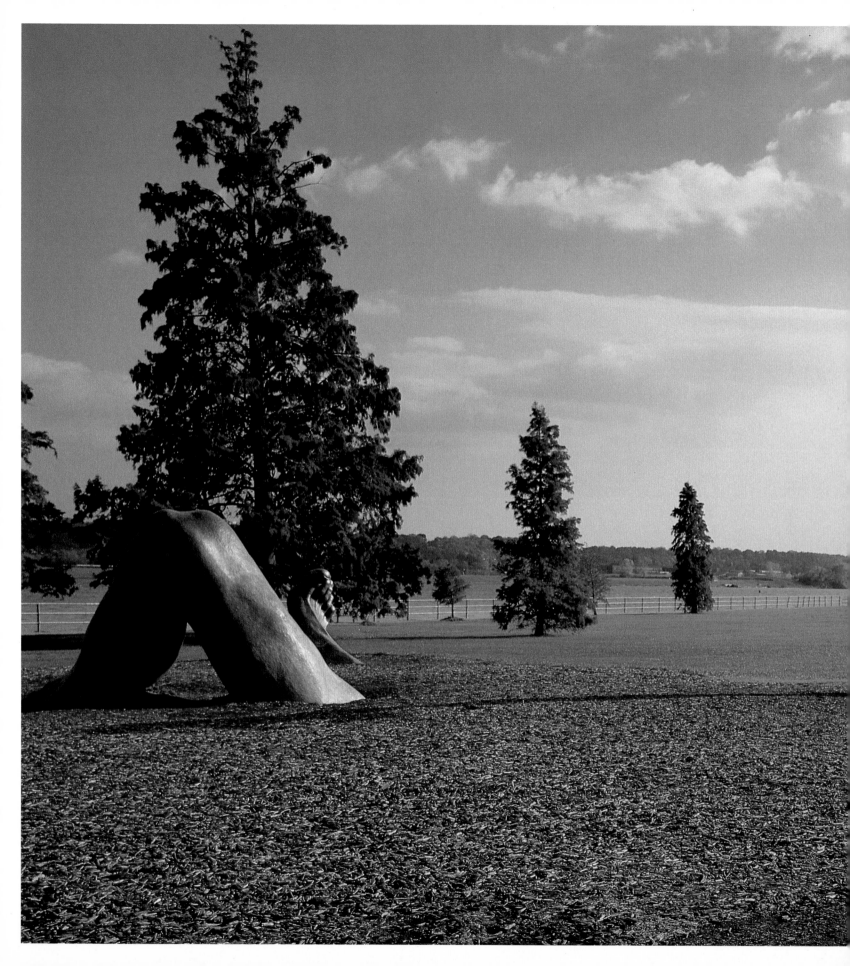

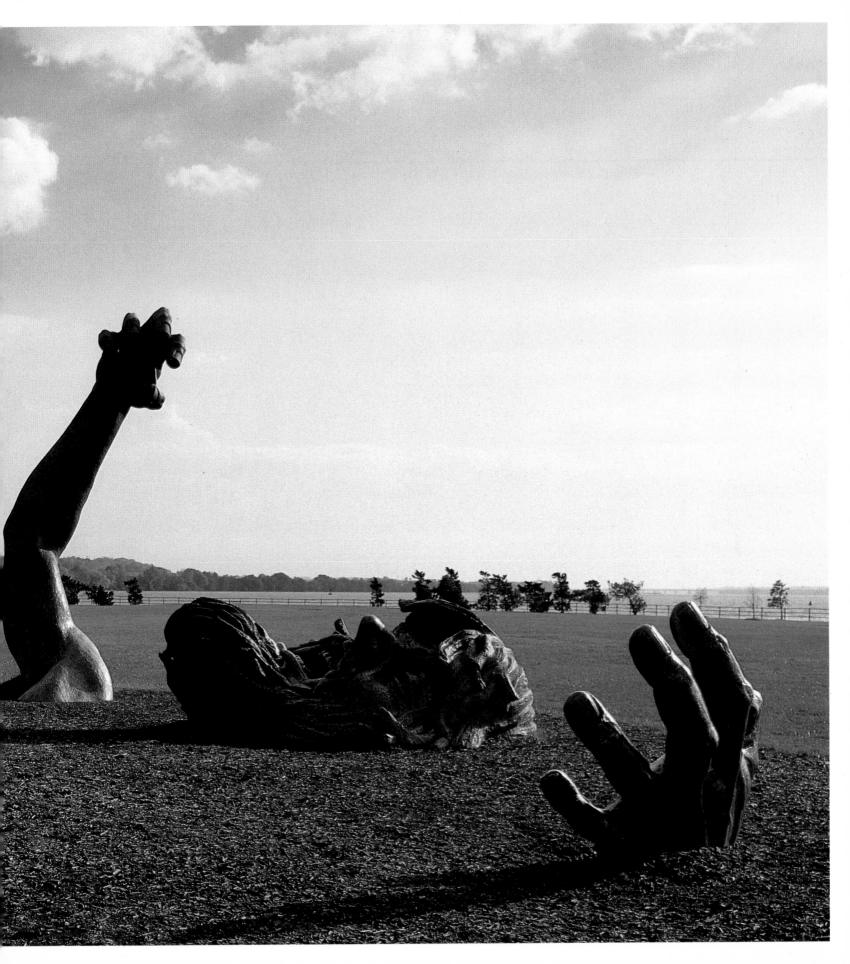

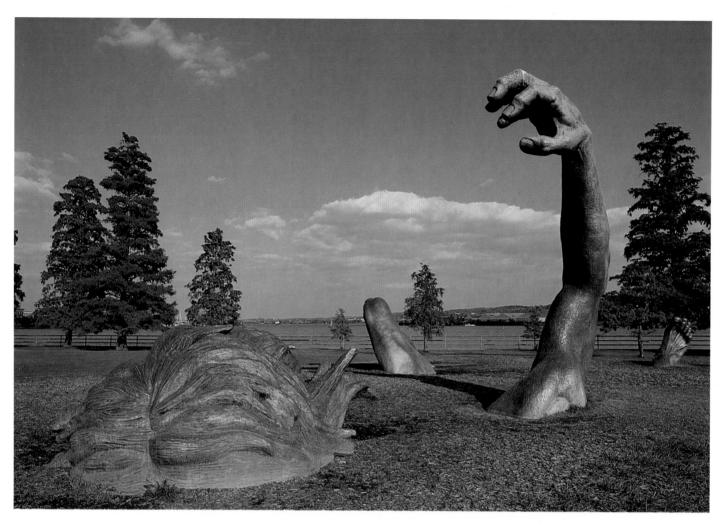

Plates 13 - 17.
THE AWAKENING. On loan to the National Park Service, Hains Point Park, Washington D.C.

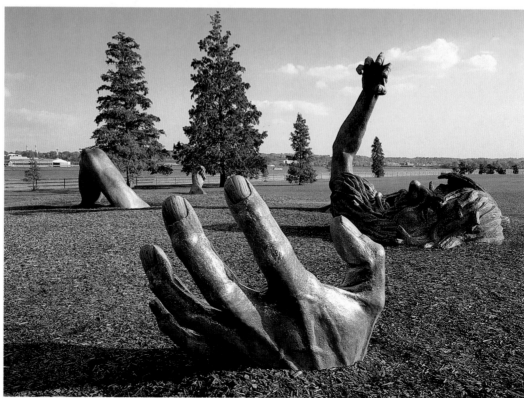

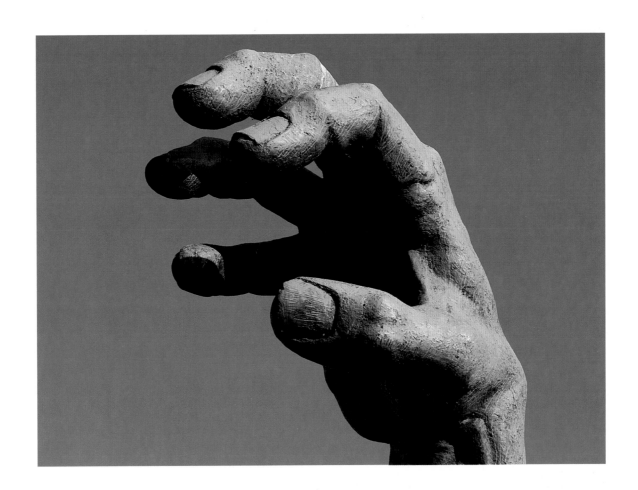

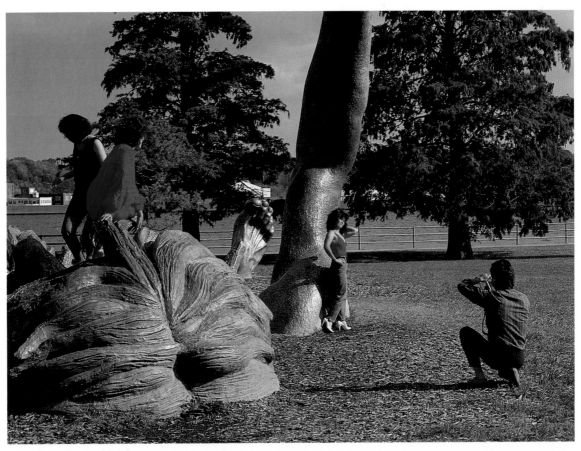

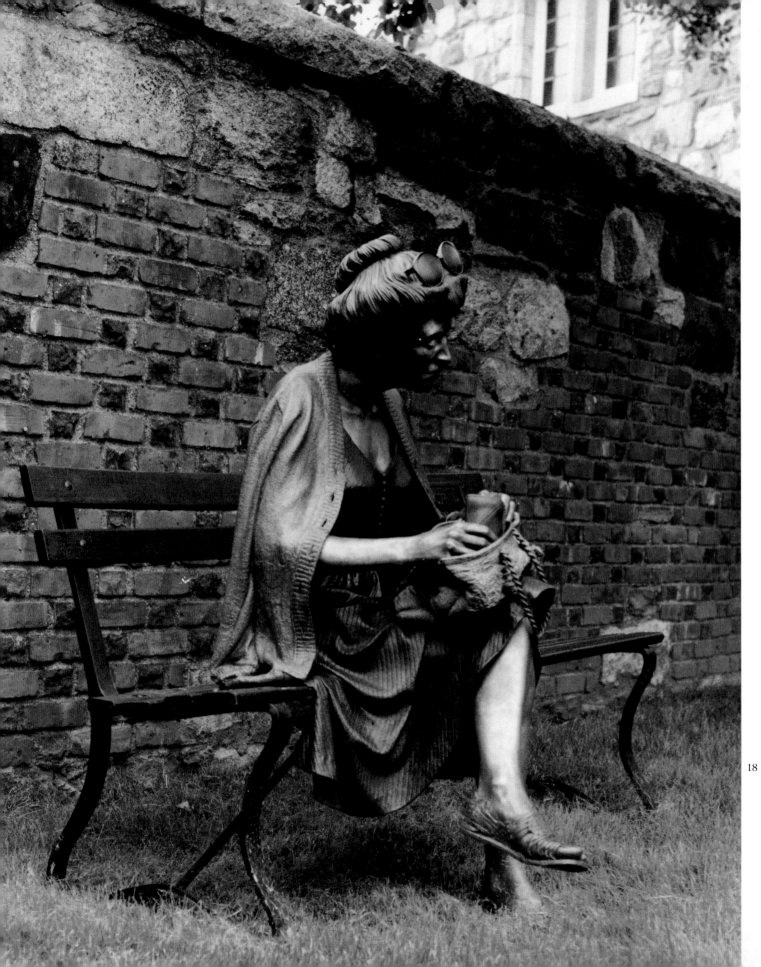

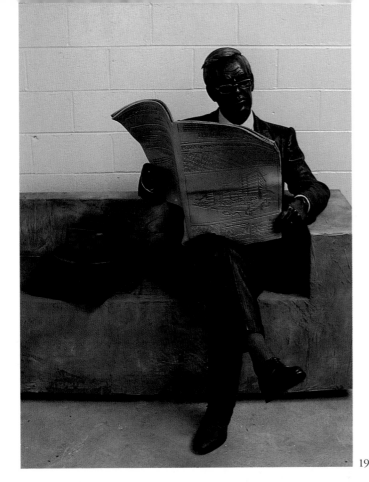

19

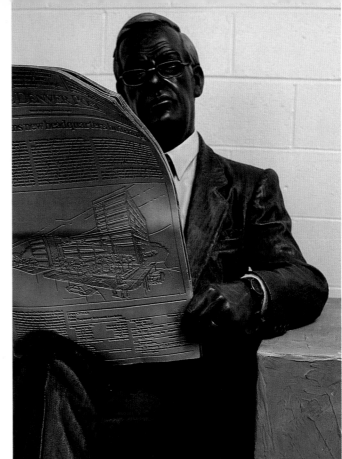

20

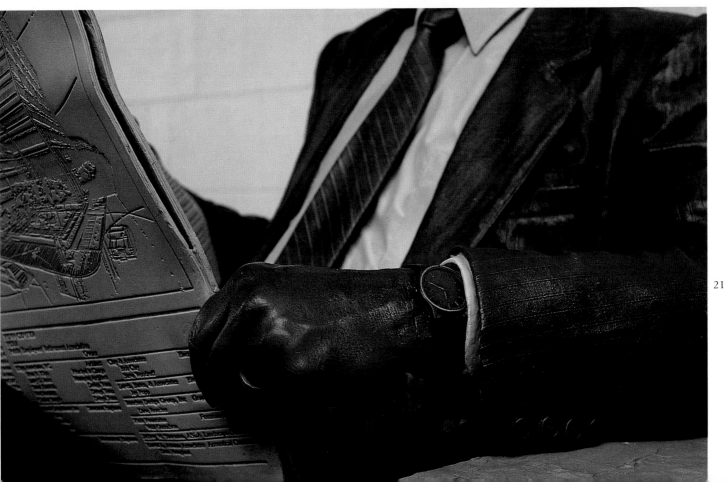

21

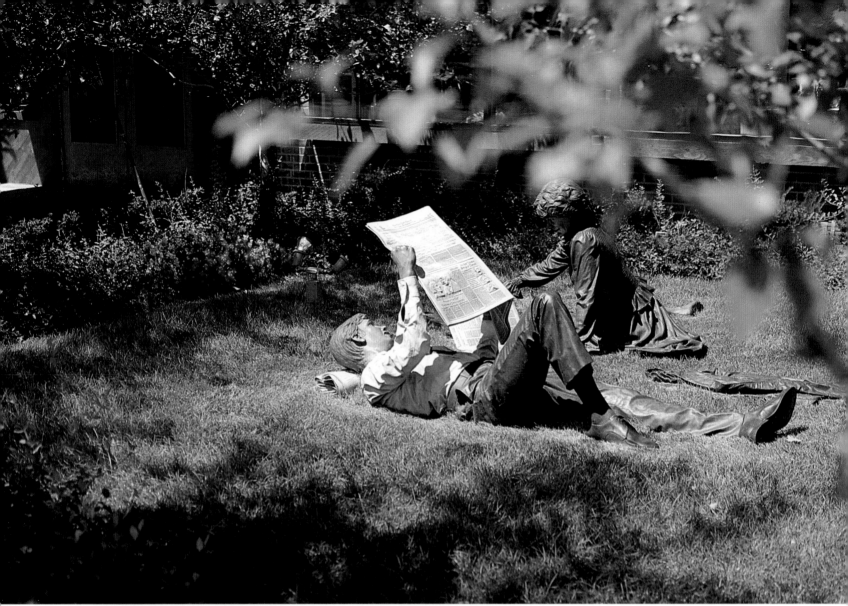

22

23

Plate 18. **THE SEARCH**

Plate 19 - 21. **WAITING**

Plates 22 - 23. **SUNDAY MORNING.**
Installations Keystone at the Crossing,
Indianapolis, Indiana, and Green Valley,
Henderson, Nevada

Plates 24 - 26. **GETTING INVOLVED**

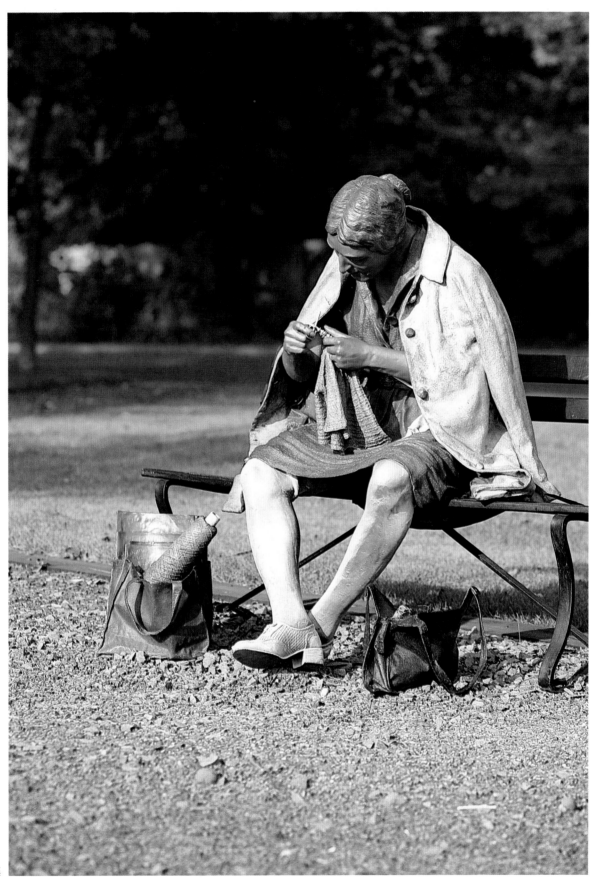

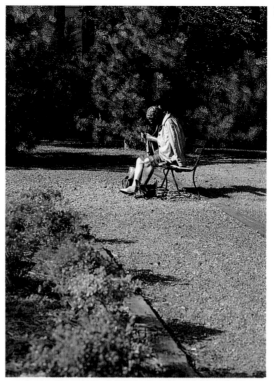

A CONVERSATION WITH J. SEWARD JOHNSON, JR.

Q: Your sculpture has been described as "hyperrealism," "ultra-realism" and "American realism." How would you characterize your work?

Johnson: I think "hyperrealism" and "ultrarealism" are both fair. "American realism"? Yes, I guess that's fair also. I'm definitely depicting an American way of life. All of those terms refer to the attention to detail in my work. In that sense I suppose that, along with Duane Hansen and maybe one or two others, I belong in that group.

But I also think those terms are imagery classifications and do not speak to other, deeper emotional classifications. I'm also trying to capture different types of relationships and to expose a humanity in those relationships . . . or even in the attitude of a single figure.

Q: Is that why you've chosen to sculpt "real life"?

Johnson: Yes. Because in our busy society—filled with so much technology and mindless distraction—it's easy sometimes to forget the simple things that give us pleasure. If we open our eyes, life is marvelous. The human spirit triumphs, if only for moments in a day. I try to have my work call attention to those moments.

Hyperrealism heightens this effect, because it often provokes a double take as its first response. People will rush by one of my works in a public place and be fooled into thinking, "That's a real person." Then they try to come up with reasons or excuses for why they were mistaken. They make up stories or little fictions to explain their initial surprise. They start talking to themselves; they look around to see if anyone caught them being startled. Or they pinch the sculpture on the nose to pretend they knew all along it was made of bronze [laughs]. At that point, the initial contact has been made.

Q: So you're trying to show people a bit of themselves. You're playing with their perceptions of what's "real" and what they thought was real.

Johnson: Yes, exactly. That's the beauty of hyperrealism. It doesn't try to be grand. It purposely doesn't frame itself or stare down at you from a pedestal. Realism never proclaims itself as art. Realism practically tries to say, "This is *not* art." As a result, it can be disarming on the first reflex. But on the second reflex, it should try to provoke.

What I'm trying to do is draw attention to the simple pleasures, to show how much fun life is. That's why there are so many humorous details in my work—people with their faces stuffed with food, guys scratching their backs and heads, kids leaving their shoes behind, a girl reading a love letter from one boy with another boy's name written on her ID bracelet.

I think that's what people like most about my work. And I like it, too.

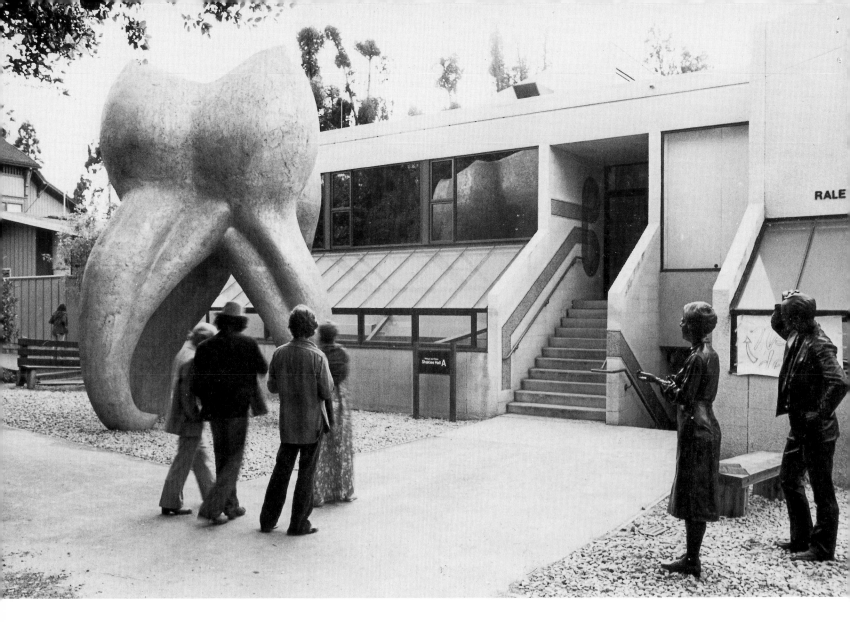

Q: Is the realistic portrayal of people in everyday situations more appealing to you than, say, abstract representations of those same kinds of circumstances?

Johnson: I have not lost affection for abstract art. But remember—public art, unlike private art, must get personal responses from a wide variety of people. Personal receptivity is, in fact, the only measure of art appreciation anyone can have. So public art,

to really succeed, must speak in a voice that can be heard by a cross-section of society.

Obviously, realism is something that reaches many more people than abstraction does. As the breadth of communication expands, so does the potency of a particular work. For that reason, I like the reach that my works have gained.

But once in a while, I do enjoy the private and more intimate correspondence that other art forms give, whether they be impressionistic or even ab-

stract. I haven't had the experience of doing an abstract piece. But I know that, as a "sender," I would get great satisfaction if I did an abstract piece that somebody liked. Because it would have to be a *very* strong communication.

Q: Do you suppose that if you did create abstract or impressionistic works, your sculptures would be more widely accepted by the art establishment and among art critics?

Johnson: Well, you know, when abstract art entered the scene, it was heralded as the art for the common man. This was supposedly because the communication was so pure it needed no intellectual detour through the mind. The form would speak for itself, viscerally, to mankind's collective unconscious.

But what happened instead? More and more people looked at twisted I-beams and piles of scrap metal, and scratched their heads in bewilderment. Then, to make matters worse, the man on the street—unlike the little boy who saw the emperor had no clothes—allowed himself to be bullied into the position of saying, "I don't know anything about art. . .I only know what I like."

This is nonsense. Art is a visual communication *received*. It is like sex or food. We respond from within without necessarily knowing why [laughs]. It's important that we do respond. It's nice, but not always necessary, to know why we respond [laughs].

Having said all that, however, I imagine it might be true that some critics would like my work better if it were more abstract. But, since I believe art is chosen viscerally and not intellectually, my response would be that it's a mistake to look toward any so-called art expert for guidance in choosing what appeals to you. The people who have to live with any piece of public art should be the most important part of the decision. After all, they are the ones who will be looking at it each day.

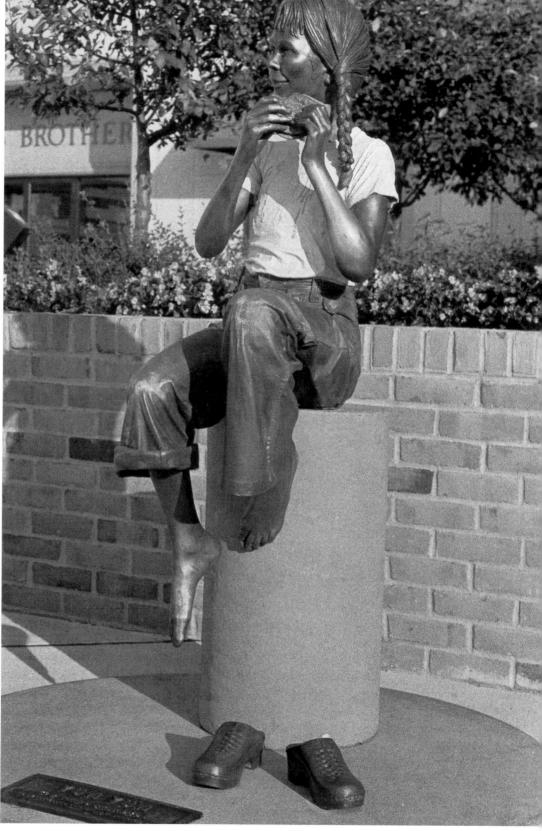

YUM YUM (above), COMPREHENSION with TOOTH (left)

27

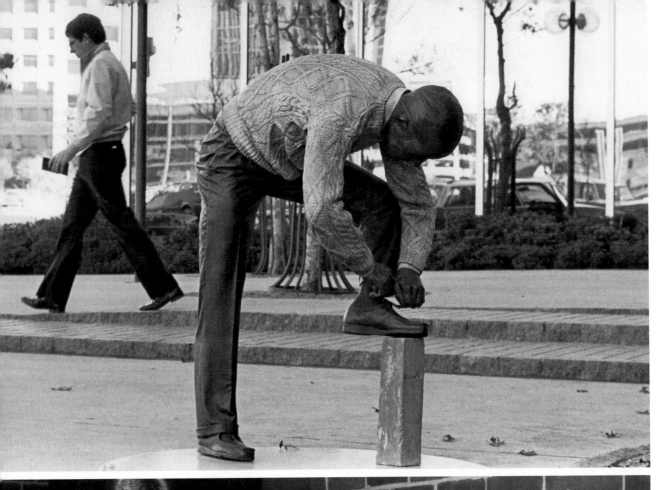

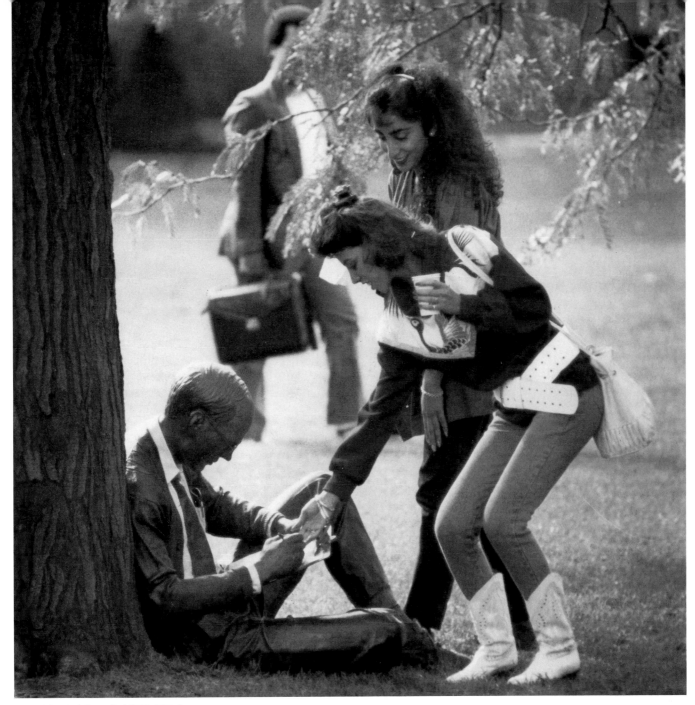

CREATING (above), TIED UP (top left), DOUBLE CHECK (bottom left)

I begin to ask myself why I got such satisfaction from creating these presences. I looked over the body of my work, and found a common strain. In each case, I celebrated a moment when the individual had taken control of his or her life. . .

I want my people to be unheroic, and in so being, become universal. But I want their act that I am celebrating, the existential gesture, to be heroic in the lowest key.

This is to suggest that we all have these moments of self-fulfillment. Perhaps we should take time to focus on them."
"Sculpture of the Human Condition: An Existential Statement"
by J. Seward Johnson, Jr., 1983

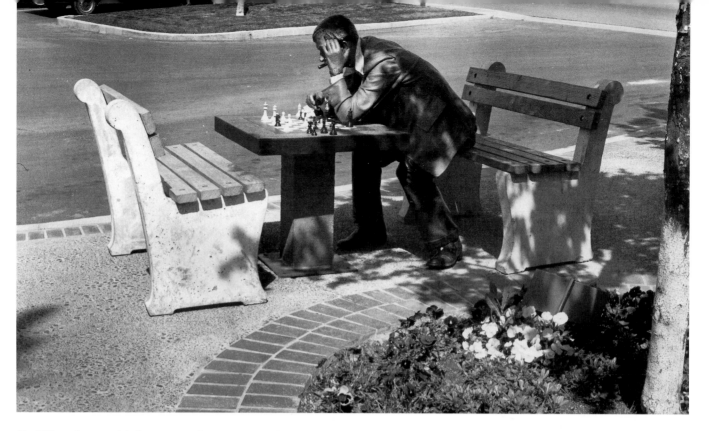

Q: What do you think your work says about contemporary America? Do you see any changes we have gone through as a nation reflected in your work over the past two decades?

Johnson: Well, there's no question that America is in a time of great social change. I mean, there were the early postwar changes brought about by the civil rights movement and then the women's rights movement. They have all been expressions of change, including changes in the way people relate to each other.

When you're in a period of change, you get very complex social situations. I have tried to capture some of them, and there are plenty more to be captured.

For instance, you get people who were married at one period in the change and now they still have to relate to each other and the outside world. What happens to their thoughts? They entered into a marriage under one set of conditions. What happens as they face new conditions?

You have all of these complex things happening in society, which are grist for my mill. And I hope for some other artists' mills, because there is rich material there.

Q: Does this also account for your desire to encourage interaction with the figures as much as possible?

Johnson: Oh, that is the essence of my work. Its great fun to touch and feel the figures, to explore every detail. The interaction is part of the art form.

Once, talking with George Segal, he said his problem with my work was that it was "just there"—the realism was there and there was nothing else to express the emotions that existed. We were sitting at a table and having a very animated discussion. He asked, "If a sculpture were made of the two of us sitting at this table talking, what artistic elements would express how we are feeling?"

Well, of course, it's clear that, with gesture and expression, it would have been possible to convey in bronze what we were feeling that day. But the interaction also extends beyond what is simply *there* to what is created in the viewer's imagination.

Which is the very same thing that happens with impressionistic work and abstract art, too. It puts the viewer to work interpreting. And where the aesthetics, or form, may not require as much interpretation in realistic work, the content does. As long as the communication is complete, then the piece is a success.

The aim of every artist is to arrest motion, which is life, by artificial means and hold it fixed so that a hundred years later, when a stranger looks at it, it moves again since it is life.
William Faulkner

COURTING (below), THE WINNER (left)

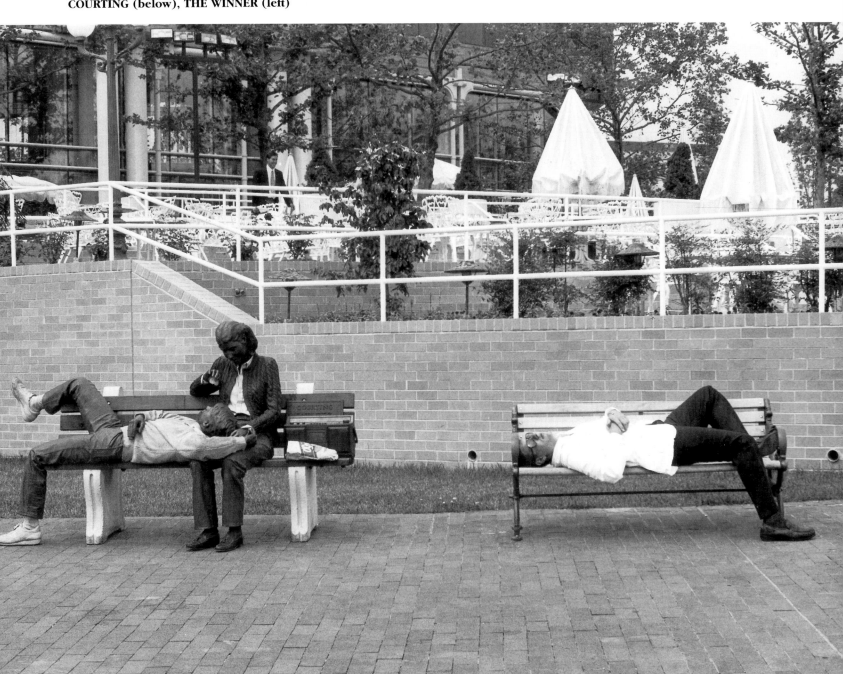

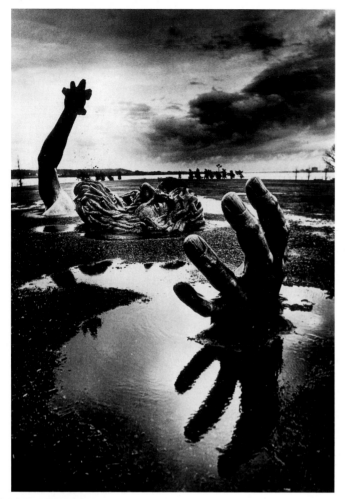 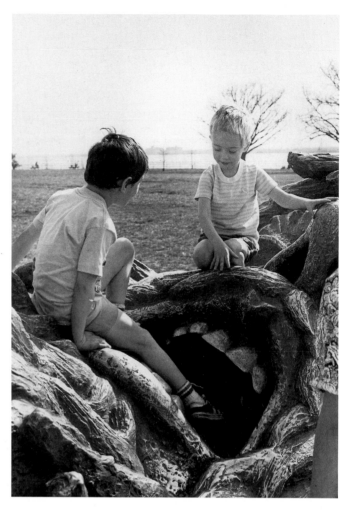

THE AWAKENING

Q: Well, what about the content in your works? It seems to me that hundreds of different stories might apply to a single figure. The possibilities are endless.

Johnson: Yes. In fact, it seems as though I've had the story of *The Awakening* described to me in at least sixty different ways. People have asked me if it's the Second Coming, or Gulliver from *Gulliver's Travels*. I've had Buddhists from the Orient write to ask if it symbolizes man breaking free from bondage, as it does in their religious tradition.

Q: Let's talk about *The Awakening* for a minute. Why did you decide to do such a large piece? Do you have plans for others that size, and what are the advantages and disadvantages of working on such a large scale?

Johnson: Oh, a piece like *The Awakening* is always exciting and a hell of a lot of fun, because the scale produces such strong effects. You get very strange images, too. Even in production, you might see someone sitting inside one of the hands hammering one of the fingernails . . . or suddenly this huge foot is coming out

of the garage door. You get wonderful images like that.

Then there's the whole concept of that scale and our collective unconscious. Every volume of fairy tales or myths has stories about giants, starting with the Greeks or before. So it's a universal icon. And you can play with the whole fantasy of identifying the giant or imagining he is the predator and you are his victim.

Q: But you have control over him because he's buried, he isn't fully able to. . .

32

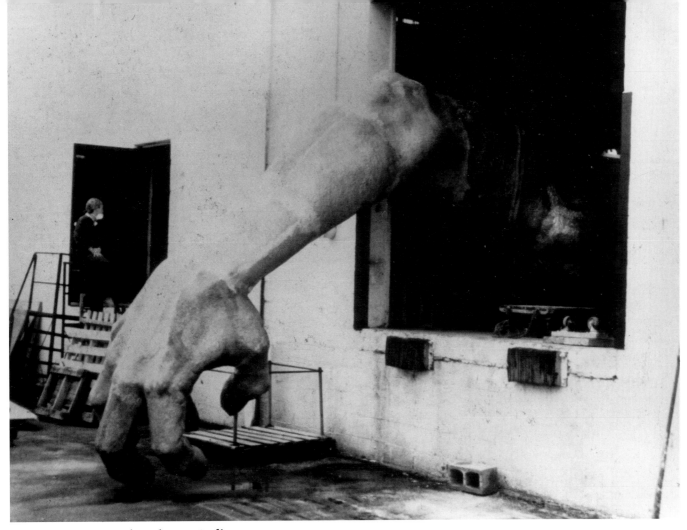

THE AWAKENING at the Johnson Atelier

Johnson: Yes, but that could change very quickly [laughs]. I've thought of other giants, too. I've envisioned one peering out of a forest with his huge hands pushing the trees aside and his feet sticking out the other end of the woods. Or in water, because water is a wonderful way to disguise. After all, it's so much easier to do a giant when most of his body is hidden. You only have to do the parts that show [laughs].

Believe me, when you're working on that scale, that çan also mean a tremendous difference in costs.

Q: What inspired you to do the piece?

Johnson: I can only remember, when I started *The Awakening*, thinking two things. First, that by making the parts come out of the earth, I could make an awfully big fellow and only have to sculpt the parts that you saw. Then, that I was going to put him on a small country road. So when you came around the corner, there was suddenly this huge giant struggling out of the earth and you had chosen the wrong time to come around the corner.

As I said, there are giants in every mythology, and there is also man breaking out of the earth in nearly every historical tradition. So the combination probably strikes a chord deep within the collective unconscious.

Anyway, it's fun for kids to get into his mouth [laughs].

Q: Would you like to do another giant?

Johnson: I would love to. But I don't think I can afford it myself again, and I haven't sold *The Awakening* yet.

33

[Johnson's] figures engender humor, but their origin is a quiet acceptance of universal human conditions, not the pathos-tinged satire of a George Segal or the ruckus caricature of a Red Grooms. There is even an element of sweetness about [his] people, but it grows out of their earnestness or their concentration on daily tasks, not from an imposed saccharine Hummel-figurine quality.

Most of all, they become part of their environments, silent participants in the lives of real people who share their space. They represent the most accessible of public art.

Allen Freeman, *Architecture,* July 1983

Q: Have you ever considered doing a large-scale thematic work like Rodin's *Gates of Hell?* Do you have an interest in depicting panoramic historical events?

Johnson: I prefer to capture the rhythm of what is happening to us right now. I like to focus on individual gestures or relationships, not on a potpourri of themes. The theme of each of my works should be simple and clear.

Q: What have been important cultural sources of inspiration for you as your style has developed? Are there any literary sources or aesthetic theories that have influenced your work?

Johnson: Well, one source that has been very important to me is William Whyte's book of time-lapse photo-

graphs of urban spaces. I have found a lot of attitude displays in those remarkable photographs. All kinds of magazine photographs of people, as well as candid snapshots of people out in public, are also very helpful sources of inspiration. And of course, just walking and watching—being aware of the poses and gestures on the street.

Daumier, the cartoonist and artist, was so expressive in gesture. He has been a great source.

I guess that every piece of work that deals with humanity and the human figure has affected me to different degrees, whether it be Rodin or Donatello or Cellini.

I'm trying to think of two-dimensional artists . . . I would say that

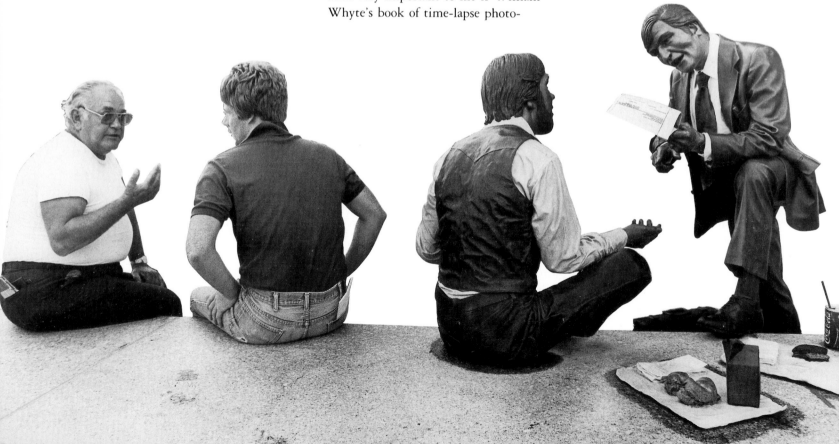

Norman Rockwell's illustrations had their effect on me. And my work has been compared with his. But I tried to use only parts of what he did, and I worked at eliminating other parts.

Q: What do you mean?

Johnson: Well, it seems to me that Rockwell confines his drawings to predisposed, perhaps even preemptive, narratives, and I try not to do that. I try to allow the viewer more freedom to impose his or her own narrative on the work.

Q: Does this get back to your conversation with Segal? Was he in effect saying that you don't give enough narrative in your work?

Johnson: Perhaps. Actually, I think I can tell what he was saying, because he was just starting to paint his fragments different colors, expressing emotions with blue and red and other colors. The abstraction of these colors was his means of expressing a mood, where the form was expressing content.

My approach has been to depict reality down to the smallest detail. Perhaps, each of us in our own way, has found a way to accomplish the same ends. Anyway, I know he prefers the rough surface of plaster to the smoothness of bronze. So that may have a bearing on how he reacts to what I'm trying to do.

**SIGHTSEEING (right),
THE BRIEFING (left)**

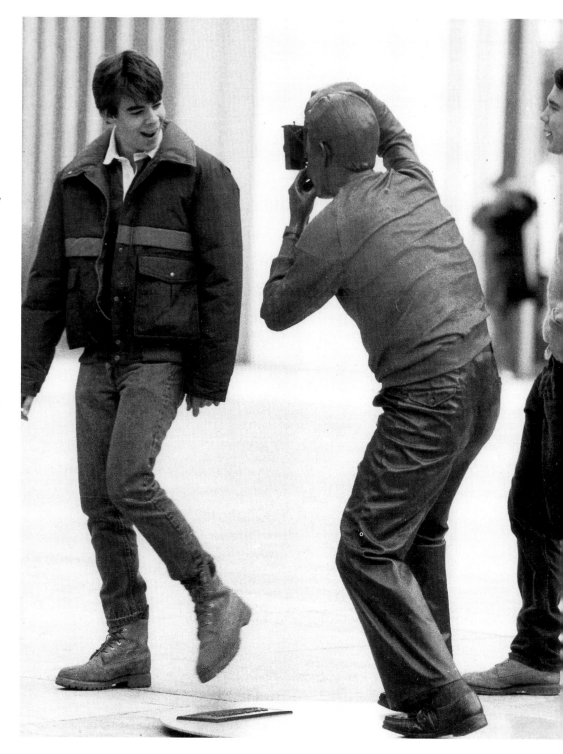

35

Q: Do you think the decision to create somewhat ambiguous narratives for your works helps to explain their popularity?

Johnson: I hope people will come up to my bronze people and want to understand who they are and how they live. I don't want to give a formula for how my sculptures should be understood.

I hope you won't be able to say *"This* is the story." I hope you'll end up thinking, "Well, *that* might be the story or *this* might be the story or maybe *this* is the story."

After all, the more you strive for a formulaic response in any piece of art, the more you need an interpreter to make sure everyone comes up with the same response. Hence, the less direct the communication becomes.

That is—and I've never said this before, but I see this as being the most fundamental fault I find with many forms of abstract art—it's not that people don't understand them, but that so many people understand them only because there's been an interpreter, and therefore it is not a direct communication.

This is not, in my opinion, how art should be enjoyed. Either it speaks to you or it doesn't. It's somehow less satisfying when the piece *and* its explanation must be taken together in one blow as the work of art.

Q: In other words, if someone goes to one of your exhibitions, they won't be reading long plaques on the pieces to figure out what they're supposed to be seeing?

Johnson: That, hopefully, is right [laughs].

Let me give you an example of what I mean. There is a piece called *The Newspaper Reader,* with the headline of Nixon resigning, out here in Princeton. My bronze fellow reading the newspaper doesn't particularly have any political statement to make. He isn't displaying any overt reaction to the news he's reading. But many people walking by his bench have a really strong reaction to that newspaper and that headline, which I've simply presented as another detail in the piece.

Q: Have you noticed any other interesting effects your works have had on people once they were installed?

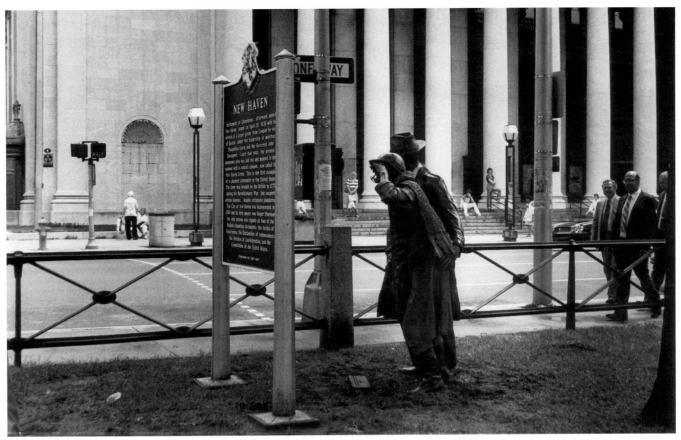

CURIOSITY (above), THE NEWSPAPER READER (left)

Johnson: Yes. Sometimes the pieces function as models, or what I call "sign posts," for good public behavior. I don't necessarily create them that way, but they occasionally end up serving that function.

In one setting, a sculpture called *That A Way* literally acts as a sign to guide people to the reception desk. And another of my pieces—*Holier Than Thou*, it's called—depicts someone putting trash into a nearby receptacle. Then there's also the woman-in-the-park story.

Q: The woman in the park?

Johnson: Do you remember I mentioned William Whyte, the architect who studied urban space with time-lapse cameras? He found that an urban space or park that was frequented by a woman meant that it was a safe space. Even the mere image of a woman in that space was like a Jungian symbol there. People felt more at ease, as if to say, "If she can sit here, then I can sit here too."

So I did a piece of a woman sitting on a park bench going through her purse, exposing her as being alone but comfortable.

Q: Did more people go into the park where she was installed?

Johnson: I know she was popular. The installation was in a park somewhere in Vancouver, and we got some very, very strong reports from up there.

But you asked for results, and I just don't know. I'm presuming it may have made a difference. After all, a presence is a presence in a person's consciousness. And if there are a criminal, a victim, and a lifelike sculpture of a person in a park, then the criminal can't help but be preoccupied with the presence of the sculpture. It's acting as a silent witness, a possible deterrent to an otherwise unobserved crime.

Q: Fascinating. You may have a whole new marketing gimmick here.

Johnson: Of course, if you advertise it, there are unfortunately too many criminals out there who would be delighted to prove you wrong [laughs].

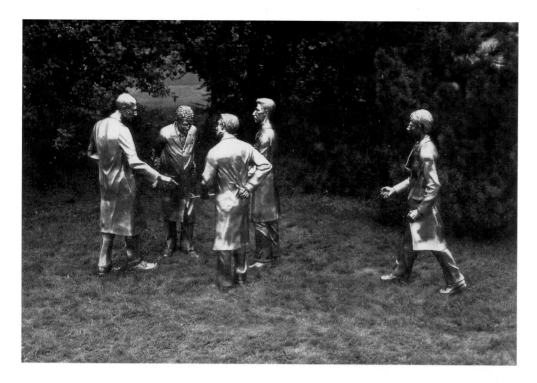

Q: I've noticed that some of your newer works depict complete vignettes as opposed to single figures. When did you start doing this, and was there a rationale behind it?

Johnson: I realized some years ago that much more complex narratives could be suggested using multifigure pieces. Human relationships can be hinted at that you can't really portray with single figures.

Sometimes you can just see the lines of force, as one of the bronze figures reaches out to another. The whole flow of bodies toward each other often expresses content very strongly.

For instance, in *The Consultation,* I started with four doctors standing in a circle conferring on a case. Somehow, the piece looked too hallowed to me, too aesthetically neat. So I added a fifth doctor coming late to the meeting to purposefully throw the work off balance and make it more realistic. People don't arrange themselves aesthetically in life, so I often will reject aesthetic form to achieve realistic content.

In that work, you can also see group politics in action. Here are the younger doctors explaining and defending their diagnosis to the older and more experienced men. The one fellow is rushing in to make his observations; the older man is scratching his back and acting somewhat bored with what the eager young doctors are

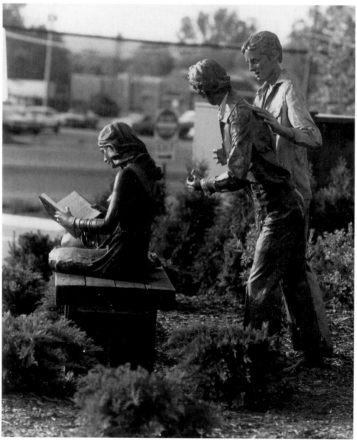

THE CONSULTATION (above left), SWEET SIXTEEN (below)

38

WAITING detail

trying to tell him. You can see all of those telling details of a scene that any of us might witness in a hospital corridor, yet have little opportunity to focus on or recall later on.

It's like what a writer does by focusing a reader's attention on particular things people do. We see some everyday action we don't normally notice presented in a new way. Then we thank the writer for making us aware that we knew this happened all along. He took us through it, and gave us pleasure. We enjoy that in fiction, and also in other art forms.

Q: Do you feel a part of America's art community?

Johnson: I feel definitely part of the greater community [laughs]. What I mean to say is that I feel my work as an artist is responsive to the greater community. I feel that the *art* community in America has begun to acknowledge a need to get to know its audience better. Perhaps I've been more aware of it than some of my colleagues. But that may change as well.

And, yes, I do feel part of the art community.

Q: Well, there is one tremendous advantage to working in bronze. You know that your work will last long after all of us are gone.

Johnson: Yes, it will . . . unless someone decides to melt it down [laughs].

Would you like some lunch? The thought of someone melting down one of my sculptures in the year 3500 is rather sobering [laughs]. I'm sure it will be easier to face after we've eaten.

[Break for Lunch]

Q: Does it bother you that critics and interviewers make so much of the fact that you are one of the heirs to the Johnson & Johnson family fortune? Do you think the implication is that "serious" artists must suffer in poverty and that, because you don't, your work is less significant as a result?

Johnson: I think that is a possible implication when I'm asked about my family. What really bothers me sometimes is the charge that I have an unfair advantage in marketing my work, insofar as I advertise and employ other means many other artists don't use to gain wider exposure. That might be true, but the other side of the story is that there *has* been genuine public acceptance of my work. You cannot buy public acceptance at any price. In fact, there was an advertisement for a college that used my work to sell their product.

I'm very proud of the fact that the sculptures generate thousands of dollars in revenues. And up until about five years ago, there was some value in being able to transport the sculptures to a setting where they would get exposure. But now that's not the case. We get many more inquiries than we can handle for sponsored exhibitions. And this goes far beyond whatever limited advertising we still do.

I'd like to think my work has intrinsic value, a life of its own. I hope this is what people are able to enjoy when they see one of my bronzes in a public place.

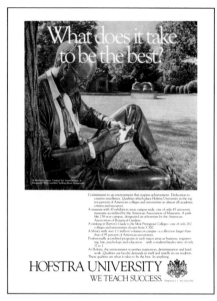

CREATING, as featured in a Hofstra University advertisement (above), SPRING (right)

Q: When did you start sculpting? Were there any early experiences that influenced your decision?

Johnson: Well, I guess you probably know that I worked with my uncle at Johnson & Johnson for several years after I got out of the Navy in 1955. Let's just say that it wasn't an ideal situation for either of us and that I left to pursue other business and personal interests.

In the mid-1960s, I really became interested in painting and the plastic arts. On my canvases, I was technically experimenting with sidelight by building the canvas out to capture the light in three dimensions. I was particularly trying to get the effect of light on a curved surface, the soft shadowing.

I was painting a nude at the time, and I just remember thinking one day, "Why go through all of this? Why not just begin working in three dimensions and see what happens?"

Stainless Girl was the first sculpture I ever did. It was done in stainless steel, which was probably wrong because it was a totally reflective medium that didn't soften sidelight at all. But I enjoyed the drama of it. And that's how it all began.

Q: When you were painting, was your style realistic?

Johnson: I was attempting everything: abstraction, realism. I was seeking personal things. Symbolism. I even did a piece that looked like Chagall, with two people flying, flying through the air. . .

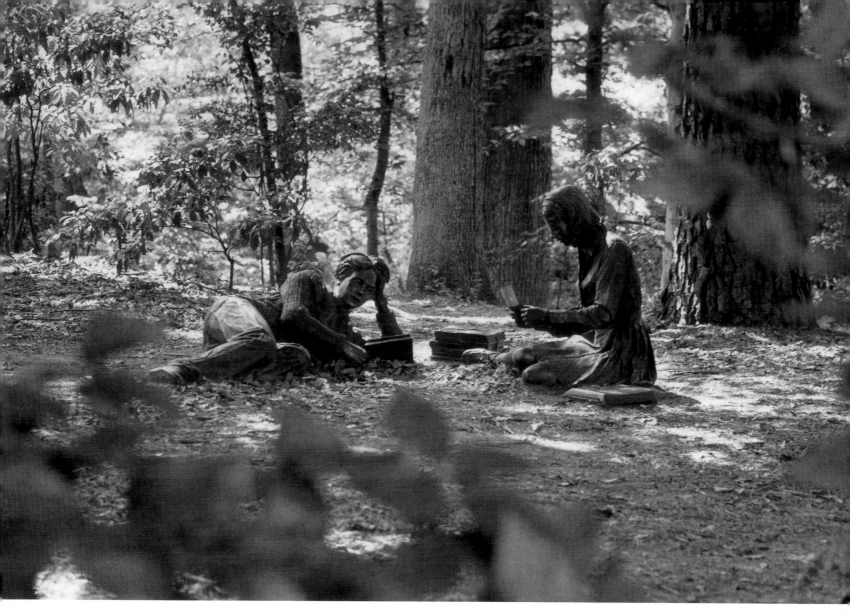

About twelve years ago, I started my realistic sculpture of human presences. Not out of a plan to be ready for a new art movement (I could not care less about such things), but to please myself by filling a void no one else seemed to be filling.
"Sculpture of the Human Condition: An Existential Statement"
by J. Seward Johnson, Jr., 1983

Q: Yet you enjoyed sculpting more?

Johnson: Not just "sculpting" in the abstract. I also became overwhelmed by a desire to see realistic human presences in some of the parks here in Princeton. In my mind's eye, I could see these bronze people sitting on the benches in the shade or playing frisbee or leaving the tennis courts. I wanted to watch other people watching them. I wanted my bronzes to convey, "This place is for us. Come and share it."

41

Q: Now that you've had a chance to see your work in parks here in Princeton and plenty of other places, do you feel your style is still evolving? Or have you found a style, and are you now concentrating more on perfecting technique?

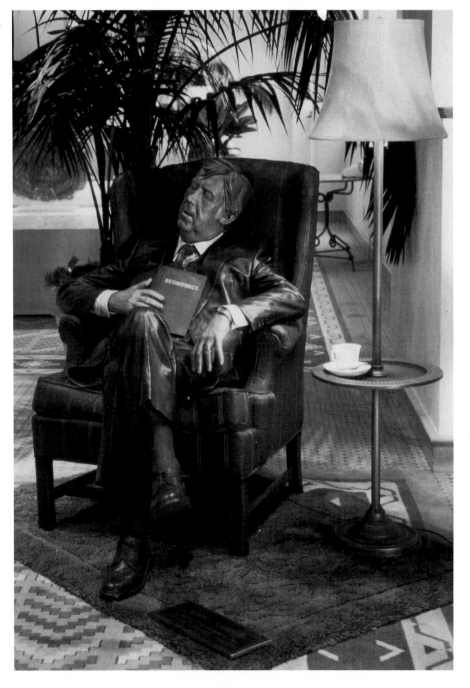

Johnson: When I think of my earlier works, like *The Newspaper Reader* or *The Frisbee Players,* they were less individuated. They don't have the very specific physical characteristics, facial expressions and idiosyncrasies that my works do now. My people these days are *extremely* individual in character.

That was a conscious decision on my part. I have discovered—and it's no secret, really—that the particular describes the general much better than the general describes the particular. In fact, the general is a homogenization and a compromise of all particulars. Your work becomes so much more vital to the viewer if you can illustrate our common humanity in simple actions that go beyond the visage or the surface of the piece.

Q: Does this mean that your work is becoming even more detailed and hyperrealistic?

Johnson: Yes, I would say that. And I have no doubt this will continue to happen.

I keep striving for greater technical realism, whether it be trying to depict the printed page in a book or skin pores or the veins in people's hands. I'm also broadening the scope of my sculptures to include entire rooms in bronze, with rugs and chairs and lamps and small tables. I did this recently with *After Lunch.*

But as far as achieving total realism is concerned, I have yet to achieve the realism of, say, the hairs on one's

arm. There are some difficult and exciting challenges that lie ahead. Details that not only add to the realism but also pass the other tests of longevity and durability. You can't make a plastic bead of sweat drop run down one of the bronzes' cheeks because it will discolor in the sunlight. But a glass one, you could. Now, whether it would stand up to treatment on the street is hard to say.

I'm always looking for universal icons—umbrellas, newspapers and the like—that people respond to immediately and recognize in public settings. Forms that are both technical challenges and also expressive.

Q: Why newspapers?

Johnson: Because so many people don't get a chance to read them until they get away from work and relax outside or during lunch.

I had done one piece with a man reading a newspaper, and I realized from its success what a powerful icon it was. So I then decided to do a series of pieces showing people using newspapers in every conceivable fashion. I had one with his leg up on a stand scanning the front page. I had one leaning against the wall. Another with a paper over his head taking a nap.

The briefcase, the umbrella, the newspaper. I've done books. A baby carriage is a wonderful form. I am continually looking for these familiar forms that strike a common chord.

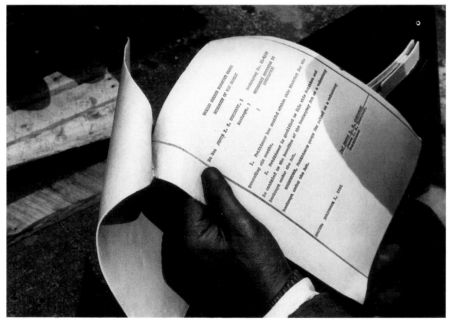

DOUBLE CHECK details (above), AFTER LUNCH (left)

Q: Are you suggesting also that the technical challenges of depicting these forms, or say of recreating the hairs on someone's arm or the pores of someone's skin, is an attempt not only to push the limits of realism but also to push the limits of the medium itself? To see how far bronze can go?

Johnson: Yes, bronze or whatever other combinations of materials. For instance, the fellow with the umbrella in *Allow Me*! There are three different kinds of metal used in that piece to achieve the effect. The umbrella had to be light enough, so we made it out of aluminum. The post of the umbrella had to be strong enough, so it was made out of steel. Bronze wouldn't have worked for the whole piece, but the rest of the form could be done in bronze.

Then we had to deal with electrolysis between the different valences in the metals. And there had to be plastic connectors and insulators to hold the whole thing together.

Q: So it's a little harder than it looks.

Johnson: Oh, technically it's very hard to cast sculpture that is supposed to stay there as long as we expect it to.

Q: Is all of your casting done at the Atelier?

Johnson: Yes, it's very near here actually.

Q: I was looking at a copy of this year's catalog from the Atelier before I came up. You said in the preface that the main goal of the Atelier is to "educate and train more artisans to help the sculptor in completing his task, to develop methods for making these processes less costly and more responsive to the artist's needs and to play a small part in whatever forces must come together to bring more sculpture into the life of 20th-century man" . . .

Johnson: Yes, that's the gist of it. I knew that one of the main things missing here in the United States was a place where artists could learn about and master the technical problems involved in metal casting. It was impossible to get trade secrets from commercial foundries at the time, and most art schools weren't teaching casting techniques to any great degree. And so that's the reason the Atelier

ALLOW ME

44

developed and flourished—as much from a desire to answer that need as from my recognition that the need existed.

Herk van Tongeren is the director of the Atelier, and he is the one who has really humanized the place. He makes it a fun place, as well as a creative forum for artists.

Q: You have a number of apprentices at the Atelier who pay tuition or receive tuition grants, and they are taught by a staff from Japan, Italy, Poland, and many other countries, as well as the United States. Do you get a large number of applications each year?

Johnson: Well, we accept about twenty new students each year, and there are usually about forty or forty-five apprentices working on the sculptures at any one time. They do work on my pieces, but the Atelier has been casting sculptures by many other American and European artists as well. And after five o'clock, the apprentices can develop their own works by using all of the Atelier facilities and paying only for the cost of the materials they use.

In most art schools, the sculpture programs have enough money to set a foundry up, but not enough money to do castings on a regular basis. And you just can't learn the technical aspects of casting during a single demonstration. You have to be doing metal pours all the time to really learn your craft.

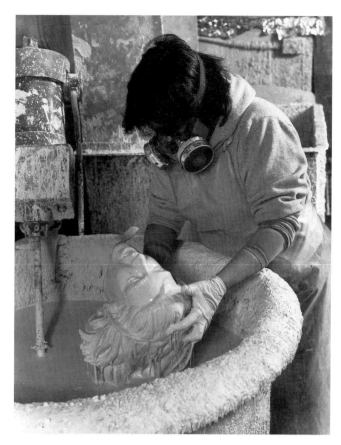

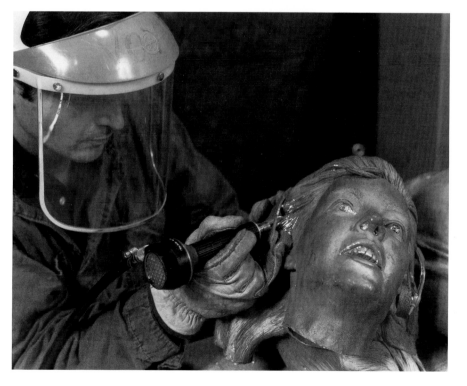

Scenes at the Johnson Atelier

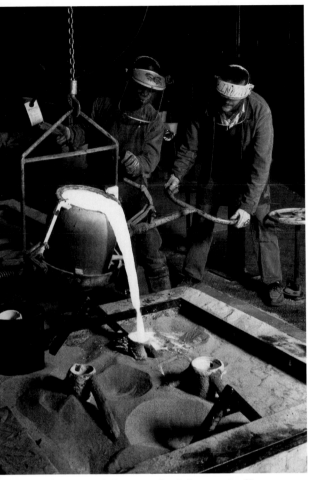

A Pour at the Johnson Atelier

Q: How often do they do metal pours at the Atelier?

Johnson: When we started the Atelier, we were doing metal pours once a week. Now it's practically every day. The repetition becomes a teaching device in a highly complex technical situation. And so the technical understanding of an apprentice who attends the Atelier for three years is a hundred times what it would probably be at most art schools.

Q: How long do most apprentices stay in the program?

Johnson: The shortest time we'll accept anybody there is three months, and we aren't really delighted to do that. I think in the future we probably won't, unless the person has had some previous time in a foundry or the like. Most of the apprentices really don't know their way around the place until after three months or so.

Q: What's the average length of stay?

Johnson: Two years, I'd say.

Q: Do you get to know many of the apprentices or see their work?

Johnson: I've gotten to know some of the apprentices in the modeling and enlarging department quite well. And if someone has been at the Atelier for several years, I may get to know him or her well, too.

But the most important thing we can do is to help the apprentices develop their work. They need to learn all the techniques we can pass along so they can begin to produce technically professional works and begin selling their own sculptures.

Q: How do you feel the Atelier has progressed since it opened, and has it produced the caliber of artistry in bronze that you hoped it would?

Johnson: The caliber of artistry in bronze depends on the artist. It also depends on the technical knowledge, and I think we have expanded the technical aspects of modern casting at the Atelier quite substantially. The apprentices are judged by their art production abilities, not by aesthetics.

It has never been my intention that the Atelier should try to direct aesthetics. Rather, the energy that a student shows in producing his or her art, despite the difficulties he or she has lived under, is what we look for in deciding who to accept and who to retain. We know the Atelier will mean the most to that kind of person, and therefore the relationship will be dynamic.

Q: So energy, motivation, and desire—plus artistic ability—are all criteria for acceptance and advancement at the Atelier?

Johnson: Yes.

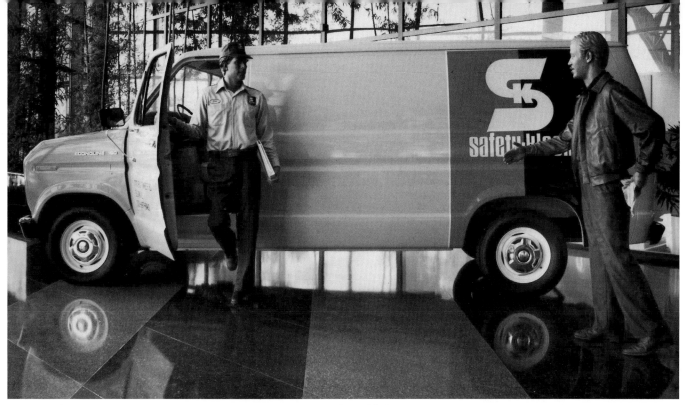

CONGRATULATIONS! I HEARD YOUR SON MADE THE BASEBALL TEAM

Q: I understand your sculptures are cast in editions of seven. Why seven?

Johnson: It's a traditional number, used by Rodin and other sculptors of the past. Each sculpture is limited to an edition of seven castings and one artist's proof. Occasionally, for various reasons, I have cut some editions short.

A few of my sculptures are unique—one casting plus one artist's proof—but we usually ask any buyer who desires such exclusivity to cover the additional costs.

Q: How does one go about commissioning a work? What artistic considerations must be inherent in the commission for you to accept it, and how much artistic control do you ask for?

Johnson: Well, it's sometimes a fight. Once in a while, it's a delight

from the beginning. But I would say that if a client truly recognizes what my work is about, it's much easier. If they want a Johnson piece to "do their thing," then they want to be the artist. I think every artist has this dilemma with commissioned work. You sometimes have to persuade the collector to accept your treatment of the concept.

Q: Any good stories about specific commissions you've taken on?

Johnson: I would say one of the most challenging was for the Safety Kleen company. They wanted to celebrate the work ethic from the beginning, and I resisted it. Finally we compromised by including it in the environment, but not as the spiritual center of the piece.

There are two guys in the piece, one getting out of an actual Safety Kleen truck, but they're sharing a joke and laughing about something away from work. The piece captures a good moment in a busy day, and a social relationship between two people instead of a strictly professional one.

With the piece I did for the Trenton Courthouse, I was given complete freedom and enjoyed doing it immensely. The closest I got to the work ethic was that the judges are discussing briefs. But their robes are parted, one guy is scratching his back, and there is a place to sit down next to them and eavesdrop on what would otherwise be a private conversation. You get the feeling they're not so imposing and aloof as they might appear when you see them in the courtroom.

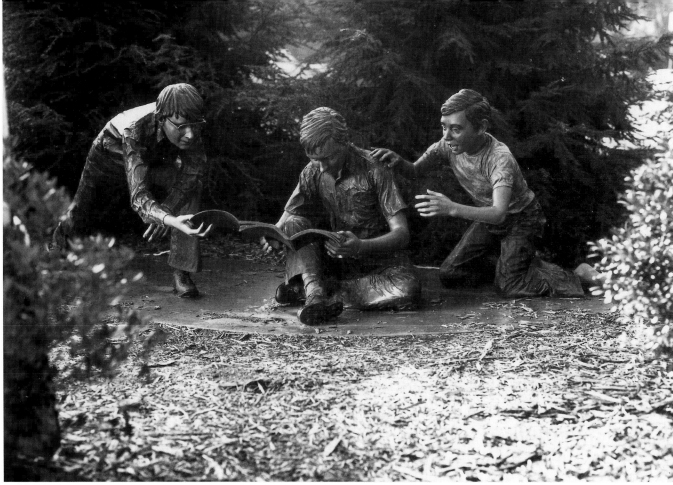

PLAYMATES

Q: Any other stories about commissions?

Johnson: Well, I was recently approached with a commission project about a historical figure—Benjamin Franklin. The clients asked for a heroic sculpture of Franklin, or a lifesize sculpture of Ben talking to some of his contemporaries. I thought I had an even better idea: Why not make a heroic sculpture of Franklin, but then put some of my contemporary figures off to the side, contemplating the Franklin statue? I love this concept of commenting on art within a sculpture, and I've used it for *Comprehension* and several works I've done.

For example, there's the one I did of the typical heroic statue of a general leading his troops into battle, with his sword raised high. Then there's a bronze woman standing directly in front of the general, posing and lifting her skirt for her boyfriend's camera. The woman takes away the statue's pomposity and makes the entire work lighthearted. She is also a bronze contemplating another bronze being contemplated by a third bronze, which is a bit like standing in a house of mirrors. It's fun.

You know, someday I'd like to get a commission to do an abstract statue on a pedestal being ignored by a guy eating his sandwich, like the guy in *Out to Lunch*. It would be delightful, but I doubt it will ever happen.

Q: It's the opposite of exposing yourself to art—denying yourself to art.

Johnson: That's right [laughs].

Q: I understand that several of your works, such as *Getting Down* and *Playmates*, have sparked some lively controversies. Can you tell me about these and how they ended?

Johnson: Well, let's see. *Playmates* showed some preteens with a centerfold, all expressing excitement and trying to impress each other with their worldliness. It's always been one of my favorite pieces. Anyway, it drew criticism when it was placed in front of Catholic Girl's School in New

48

Haven by error. That obviously wasn't the most appropriate spot for it, and I didn't place it there. But if I had been in charge, I could easily have been guilty of doing that [laughs].

As for the fellow in *Getting Down*—with the boom box on his shoulder—that was a serious piece for me, inasmuch as I really felt I brought out his humanity. He is really enjoying his music, completely involved in it.

Anyway, the image of a black teenager taking over everyone else's acoustical space wasn't acceptable to the local chapter of the NAACP in New Haven, and the controversy began.

It seemed to me that this defensive posture showed how real the phenomenon actually is in many urban areas. However, the NAACP felt it was an improper subject to depict in a work of art.

I take great exception to this, because it makes art the slave of social morality and doesn't acknowledge the reality of what the piece depicts. The fellow in *Getting Down* is doing what I celebrate as an important thing—finding a part of himself—and not doing something that's just a trained social response.

Q: How did the controversies end?

Johnson: In the case of *Getting Down*, even though the NAACP objected to the piece, all of the young black teenagers in the park where the piece was displayed were up in arms when they found the work might be removed. It was on temporary exhibit anyway, but they had grown to like the piece. The sculpture stayed at their insistence, until the exhibition time was up. Then it was taken away.

Both *Getting Down* and *Playmates* were on temporary exhibition.

Q: Just out of curiosity—did the centerfold shown in *Playmates* actually have a depiction of . . .

Johnson: Of a nude? Well, she was nude from the back. But she was getting ready to turn around. . . . It was flirtatious, but by no means even softly pornographic [laughs].

Q: Just curious about that point.

Johnson: Wait until you see my next piece [laughs].

Were art to redeem man, it could do so only by saving him from the seriousness of life and restoring him to an unexpected boyishness.
Jose Ortega Y Gassett, *The Dehumanization of Art*

PLAYMATES detail

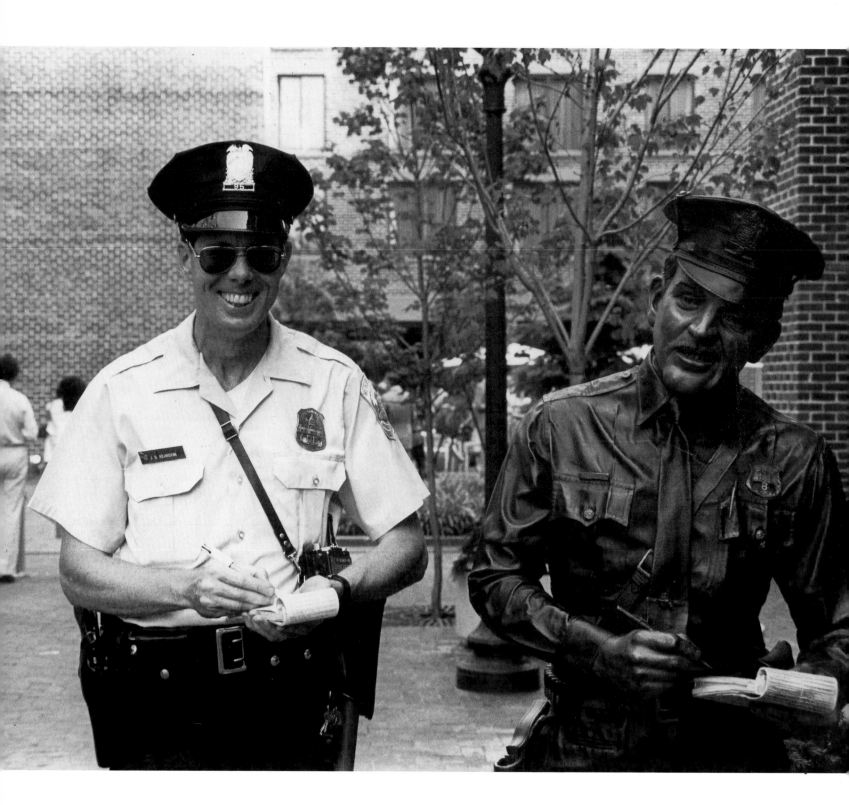

Q: There's so much humor in a lot of your works, especially in the details. In fact, what we were talking about earlier seemed to indicate that the details were primary signs of interpretation for the viewer. Is that true?

Johnson: I would say secondary, quite frankly. They are guideposts for getting into the narrative of the piece, and they can be used to explicate what is going on.

Q: Can you give me some examples of the kinds of details you like best that emerge during the seven castings of any piece you complete? How do the details change as the work is recast, and are there castings that have been altered for specific sites?

Johnson: Well, there's one where a chess player, instead of playing chess, is sitting in Kathy Gallaher's restaurant in Los Angeles reading a menu. So there was a definite change made for a specific environment.

There are so many different details I love. I think my favorite is the shoe that has come off and is lying on the ground behind the children in *Crack the Whip*. More people have fun with that detail, because it tells its own little story. Also, it is in a separate place from the circle of figures in the piece.

So, just as in *The Consultation,* that detail puts the piece a bit out of balance and reinforces the realism I'm seeking to depict. Also, most people don't discover that shoe until their second or third visit.

Q: Are these details part of your initial concept, or do they develop as the piece takes shape in the studio?

Johnson: Very often the latter. The policeman's ticket in *Time's Up* is a fun story about that.

When I was thinking of what charges to write on the ticket, the actual policeman who was the model suggested that I could be the recipient of the first ticket. I have forgotten what it was—disturbing the peace or insulting an officer. It was terrific. He understood my intent, and added his own twist to it. Just that interchange was a lively dynamic in itself, and it made its way into the work.

In fact, I had asked the officer what he would do if he had gone around the block three times just to give the guy a chance and there still wasn't any money in the meter. I said, "What would you say?" And he replied, "Shit." So I caught the mouth saying that, which was a gesture in itself and made the piece more truthful.

One of the buyers of *Time's Up* asked if he could have his name put on the ticket instead of mine. I was so delighted with that, because it showed identification with my purpose, the humor and self-deprecation.

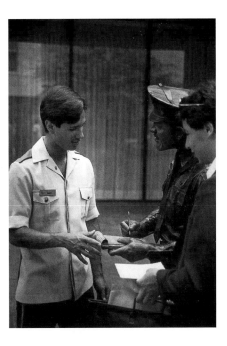

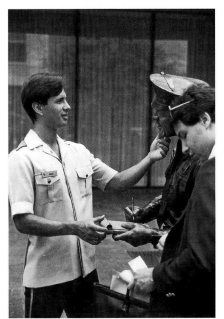

TIME'S UP (left and right)

51

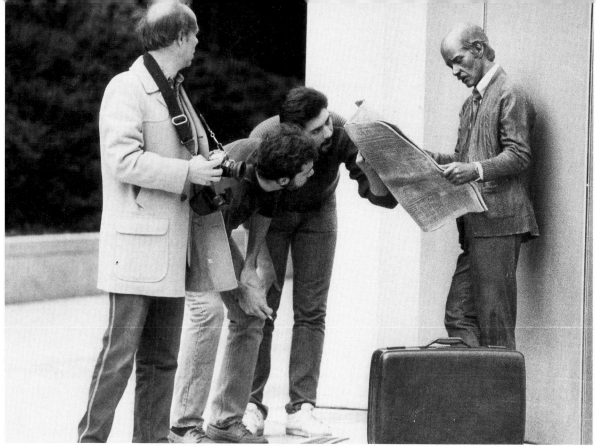

CATCHING UP (above), GENERATION BRIDGE (right)

Q: I remember being struck by one piece where a girl is feeding her boyfriend a potato chip.

Johnson: Yes, that one is called *Courting.* These potato chips were technically very difficult to produce. It took a long time to get them right—lots of very complicated experiments.

Some other terrifc details are those you notice only on very close inspection, like a bandage on an arm or the green grass stain on the tip of a tennis shoe.

Who the hell would go to so much trouble? It makes for so much realism, and people enjoy that.

Q: In other words, you can just glance at these pieces and get an impression. But subliminally within

that impression, there may be a lot of messages coming in that you either will or won't pick up. You may not register the fact that you see a bandage on one of the figure's arms. But because it is there, you have experienced a greater illusion of reality.

Johnson: Yes. You are surprised to find that what you thought was "only a person" turns out to be a bronze sculpture.

Then there is the second thing. Your immediate response has an afterlife. You bring your friend back to have that first immediate response, and you pick up more of the tinier details the second time around. Then you have a completely different experience of the work that perhaps allows you to create another, more complex narrative. Returning to view a piece

in different moods causes different interpretations of the sculpture's meaning.

Q: It's as if you went to see a movie that you really enjoyedand then watched the movie again and saw something deeper going on.

Johnson: And even if you finally think you've discovered it all—everything there was to discover—the final mystery is that there might be something else yet to see.

Mystery is important, and of course, realism is supposedly the antithesis of mystery. So it is very difficult to build mystery into realism. But I would say that details are the only way to do it—if you have a little treasure hunt built into the works.

52

Q: I notice that quite a few of your sculptures have children in them. Do you think that having children has affected your work? Have the different stages of their lives, and your role as a father, caused your work to change over the years?

Johnson: I think that becoming a father has profoundly affected my work. It has softened me and made me more aware of the innermost parts of people.

There is a young girl in *Generation Bridge* who is moving her fingers in front of her lips, as if she were playing the piano. I saw that gesture so many times when I was playing with my daughter. She always did that. Whenever I look at the work, I want to hug that child. But that attitude, brought to a piece by the artist, helps to instill any artwork with a living presence.

Watching my children has made me wiser and more aware.

Q: Your later works also seem to deal quite a lot with communication between the generations. I'm thinking especially of *Sunday Walk,* with the grandfather and the little boy, or *Generation Bridge.* And there are others.

Johnson: Well, *Sunday Walk* came about because of the humanity of my father-in-law, who had so much love for his grandchildren that it just overwhelmed me. I remember how he expressed it.

My children have made me more conscious of other children, too. I'm able now to project into those other children a little more knowledge of life. I pick up what their gestures mean.

But I think having children is a very humanizing experience. It makes you more vulnerable and sensitive.

Q: And parents find that their children make them acutely aware again of the learning process.

Johnson: Yes! Very true. But there is also a danger in sculpting children, because they can be oversentimentalized. This is certainly true of the Hummel figurines and a lot of kitsch art.

I make it a point not to idealize children, while capturing their spirit and pure joy of living. Like real life, the kids in my sculptures argue over ice cream cones or walk around with sandwiches in their mouths. Whatever it takes to cut the sweetness and show children as they really are.

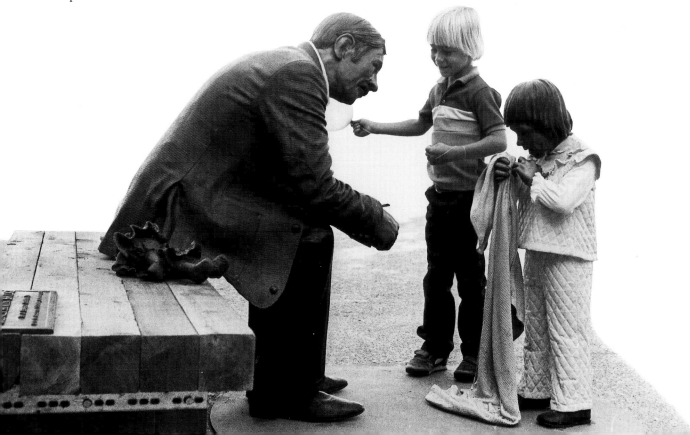

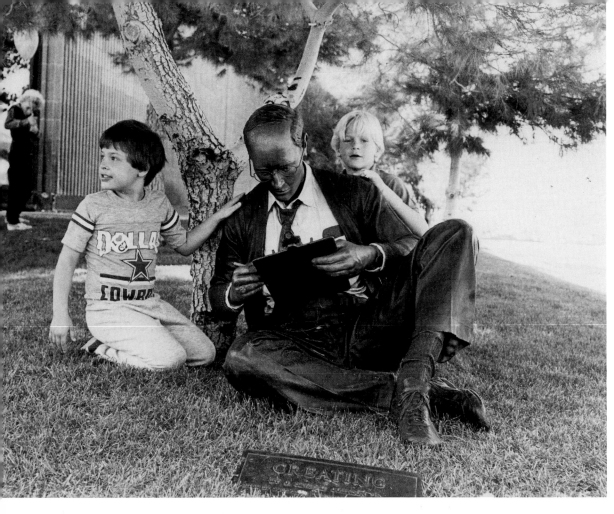

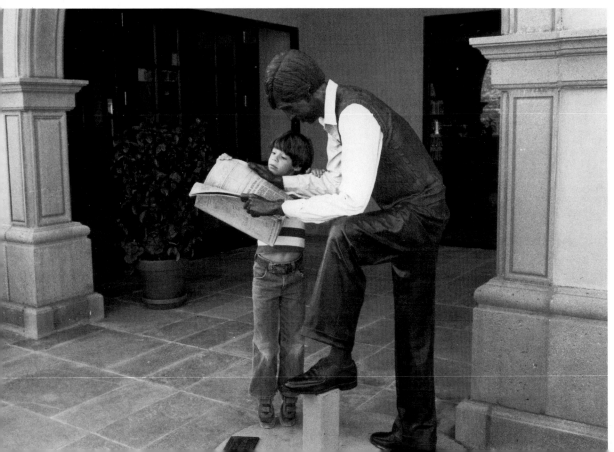

Nov. 21, 1984

Dear American Nevada

Corporation Thank you for bringing

The Sculptures my favorite Ones

Were the Pause and Just a taste

Love Deron Grade 1

Fay Galloway

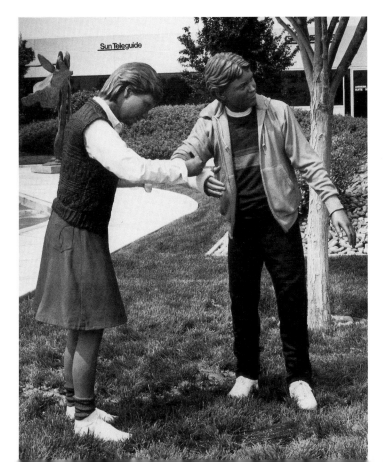
The Pause

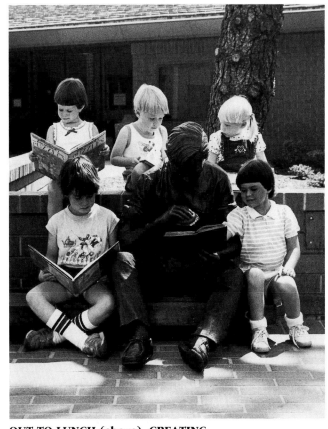

**OUT TO LUNCH (above), CREATING
(top left), POINT OF VIEW (bottom
left), THE HERO (below left),
ALLOW ME detail (below right)**

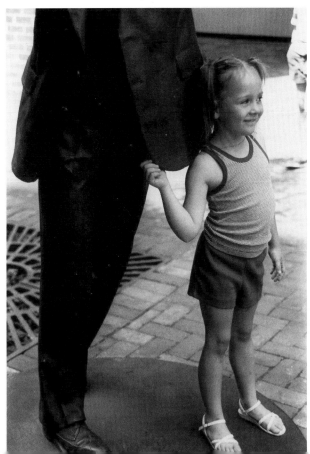

Q: What do you look forward to accomplishing in the future? What do you wish to communicate through your work to future generations?

Johnson: Well, I would say one thing that would please me would be to have expressed the universality of human experience over time. That we are doing many of the same things they did in Rome or Greece or will do in the future. That there is a common thread.

This can be very reassuring for people in our time, to see themselves reflected in the art of another age. I think that's really what I most want to impart through my work.

Q: It's interesting that you mention Greece and Rome. Because, in those societies, the perfection of art was the completely realistic representation of the human figure.

Johnson: Yes. Art says know yourself first. The human figure is the first icon. And it is a very complex relationship when you have an inanimate figure you can touch. You can be familiar in all of those ways we are not normally allowed to be.

Q: Maybe the human form just frightens a lot of people.

Johnson: We're inhibited by. . . well, it isn't the human form, really, because the human form encompasses the person. I can't invade your personage. I mean, we have a formal relationship. I can't start playing with

your nose or something [laughs].

But to be able to do that with a bronze sculpture can suddenly be quite liberating. People walk up to my sculptures and act quite familiar with them. Then they look over their shoulder to see if anyone has caught them doing it.

And sometimes the bronze gets a little shinier around the breasts and other places. We often see this after an exhibition has closed and the pieces are shipped back to the studio [laughs].

Q: If there is one word you would like to spring into someone's mind when they see your work, what would that one word be?

Johnson: I have the concept, but it doesn't work with just one word.

I would love people to say, "How truly human," or "Isn't that so?" because those statements would be acknowledgments that I've touched the truth in my art.

CELEBRATING THE FAMILIAR

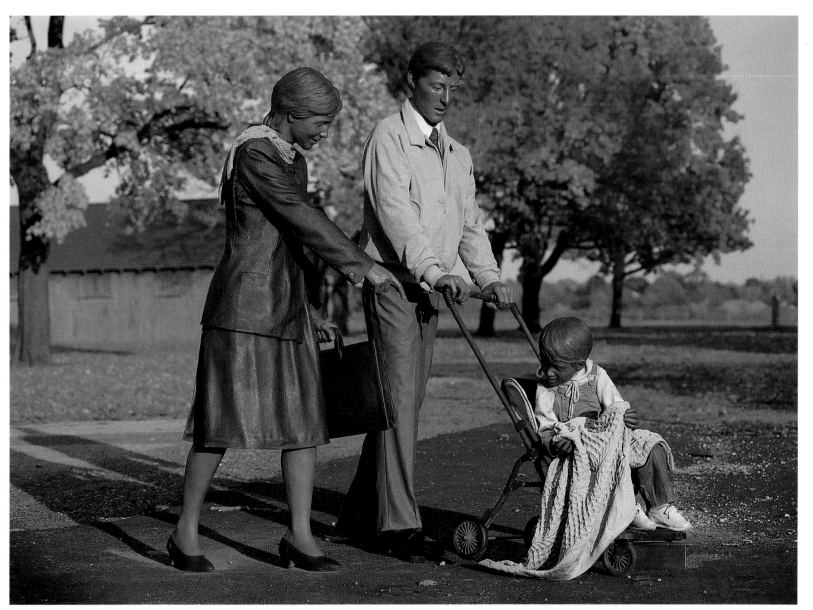

Plate 27. **CHANGING TIMES**

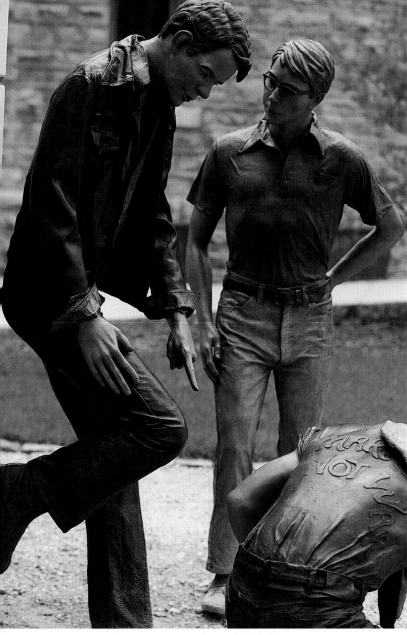

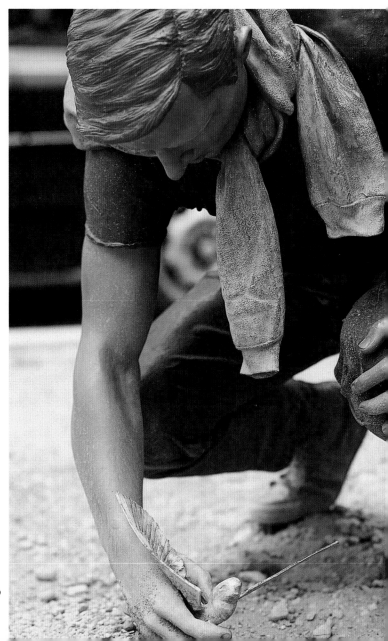

Personal receptivity is, in fact, the only measure of art appreciation one can have. So public art, to succeed, must speak in a voice that can be heard by a cross section of society.
J. Seward Johnson, Jr.

Plates 28 - 29. **PASSING TIME.** Installation Morse College, Yale University, New Haven, Connecticut

Plate 30. **THE SKATEBOARDER**

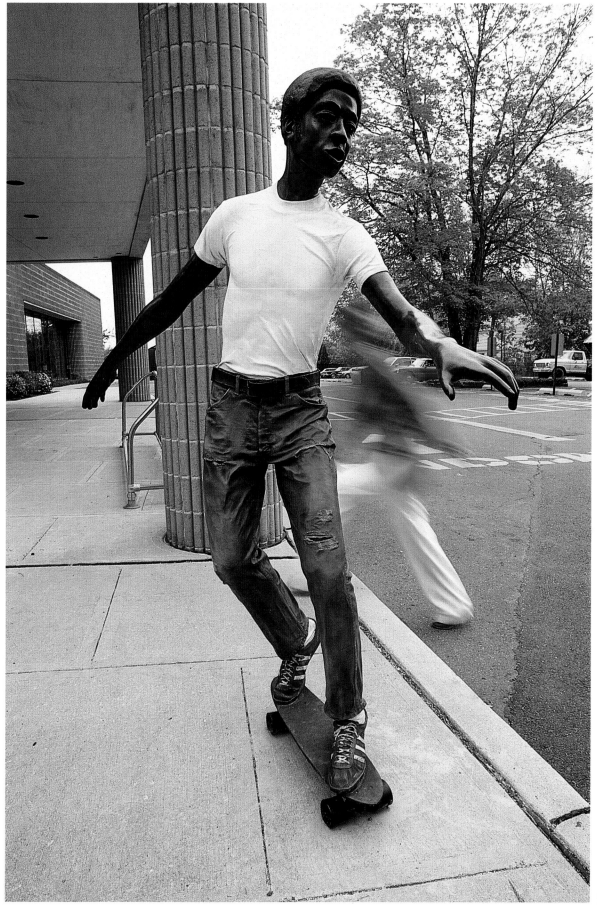

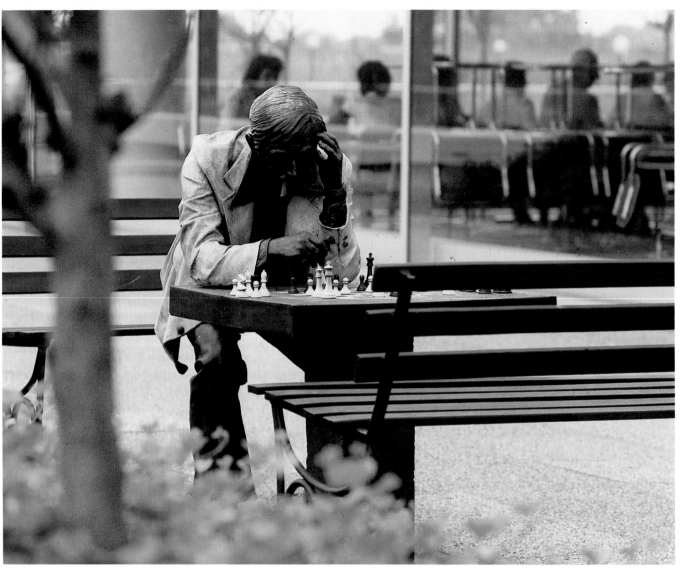

Plates 31 - 33. **THE WINNER**

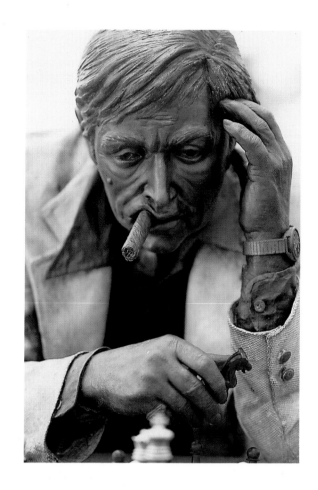

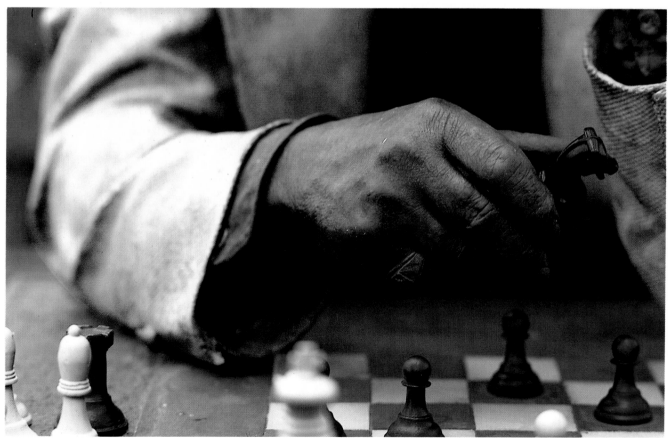

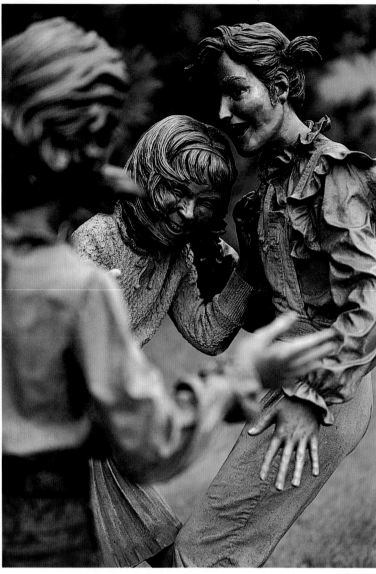

Plates 34 - 35. **NO HANDS**

Plate 36. **WAITING TO CROSS.** On loan to the Capital Children's Museum, Washington, D.C.

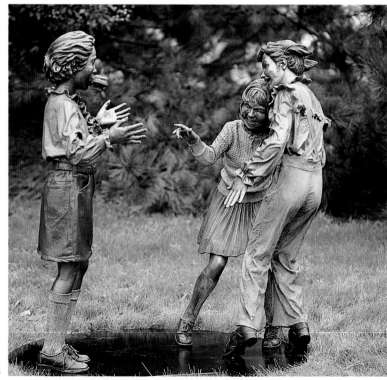

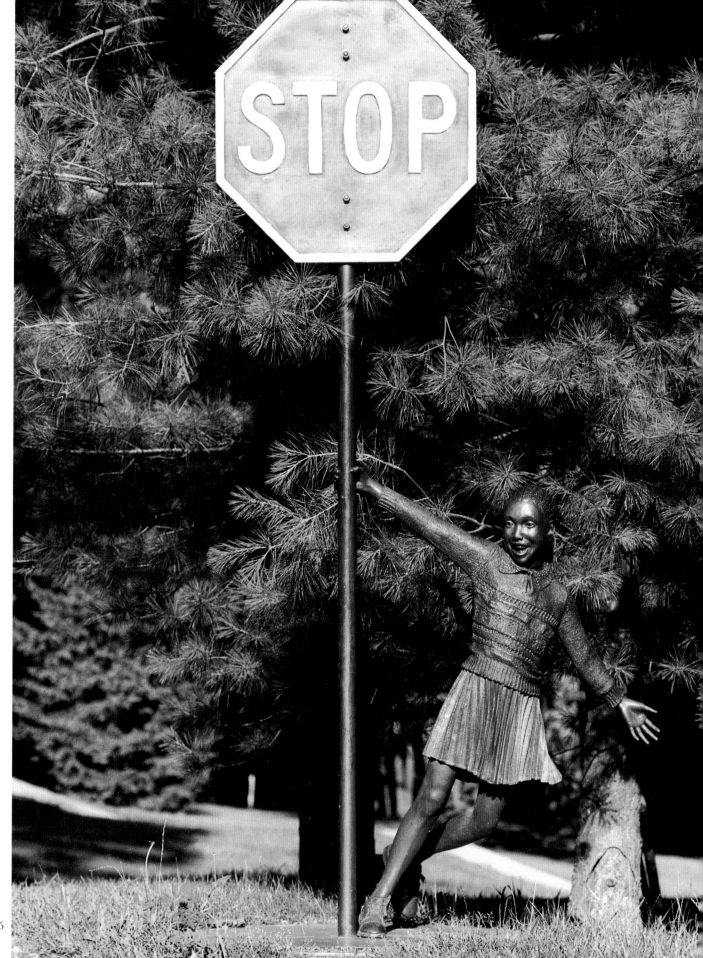

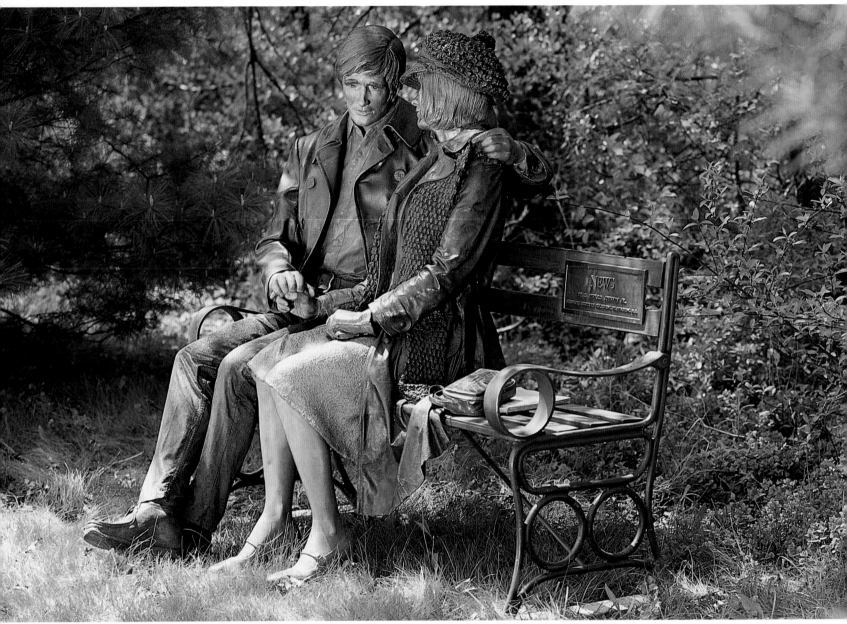

Plate 37. **NEWS** Plate 38. **SIGHTSEEING.** On loan to the ARCO Sculpture Garden, American Film Institute, Los Angeles, California

In the end, Johnson gives us ourselves. And we seem to enjoy that look in his mirror. His clues to the familiar also serve as a reminder that we need—and perhaps deserve—art that lives out of doors . . .
Sally Freidman, *After Dark*, October 3, 1984

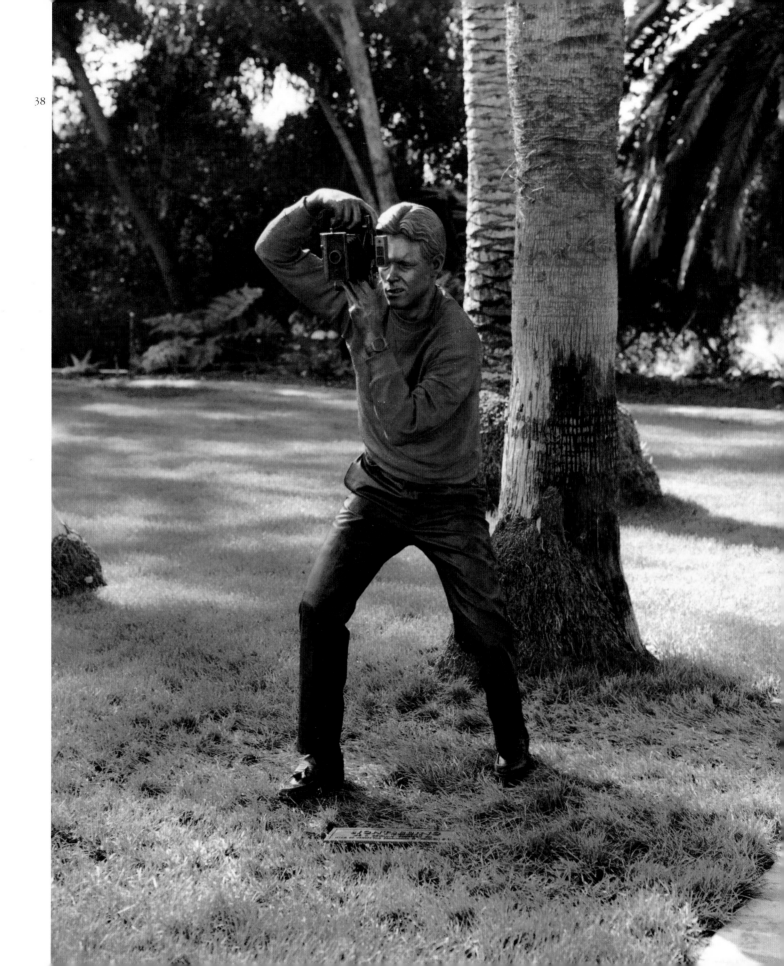

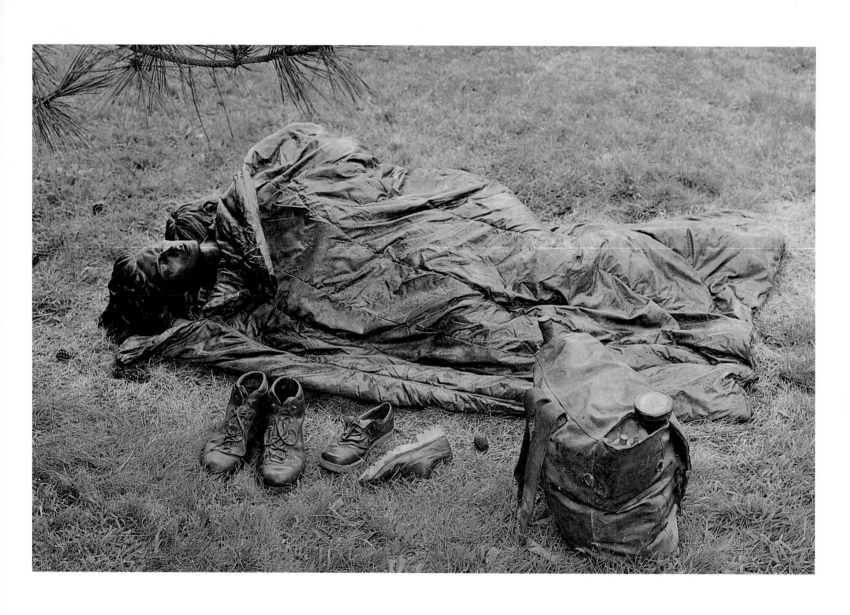

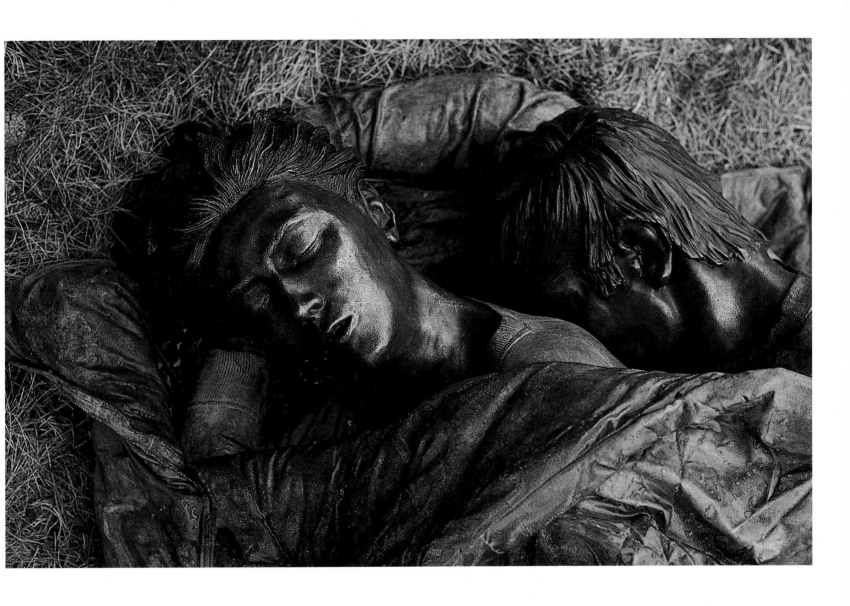

Plates 39 - 41. **THE GREAT OUTDOORS.** Installation Vail, Colorado

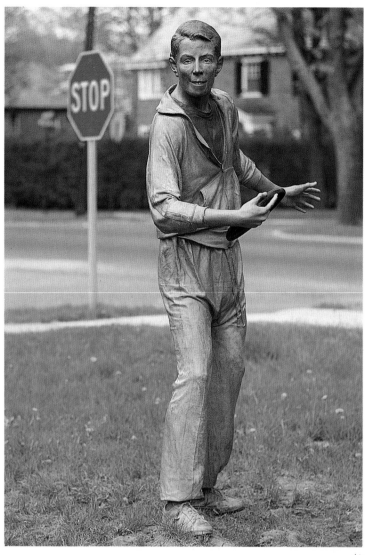

Hyperrealism generally receives a double-take as its first response. . .In this type of relationship with art, we will look for excuses or reasons to comprehend what we have seen.

In so doing, we may seek the work's narrative to explain our initial response. At that point, the artistic communication is complete.

"Sculpture of the Human Condition: An Existential Statement" by J. Seward Johnson, Jr., 1983

42

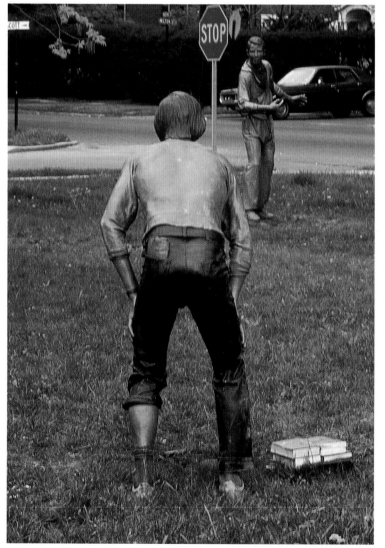

43

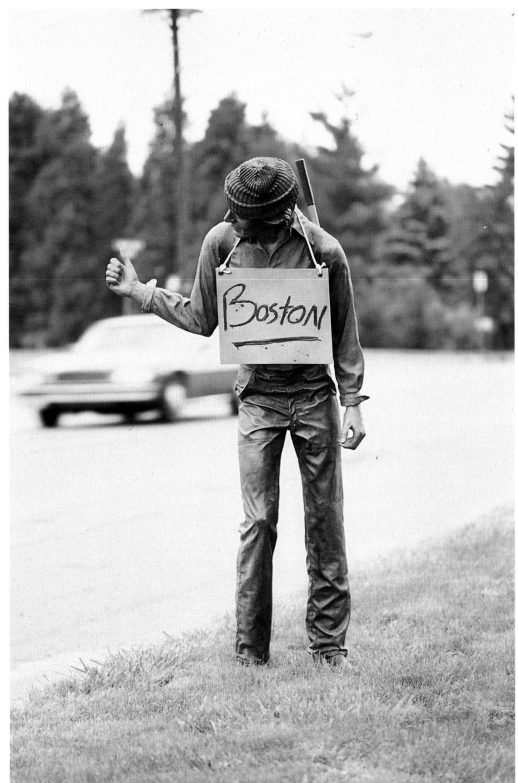

Plates 42 - 43. **TIME OUT**

Plates 44 - 45. **THE HITCHHIKER.** Collection Hofstra
University, Hempstead, New York

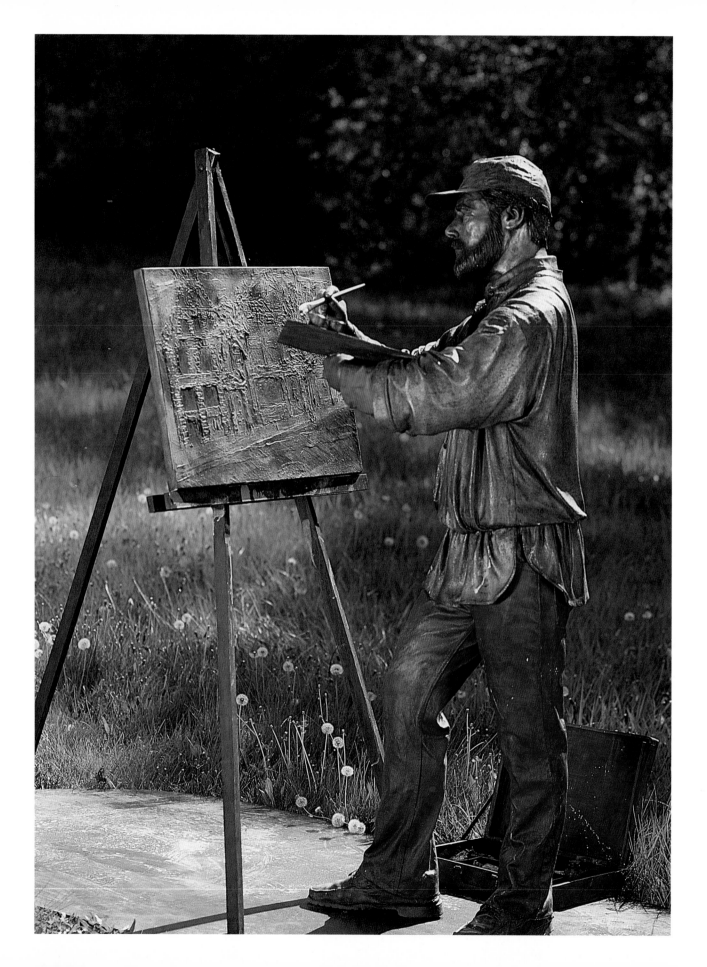

Plates 46 - 49. **THE RIGHT LIGHT.** Collection Trammell Crow Company, Dallas, Texas

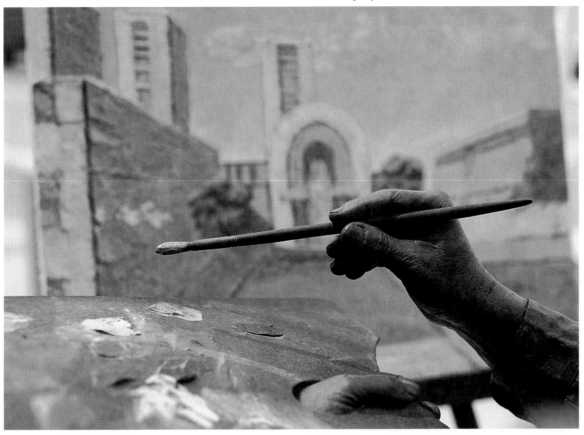

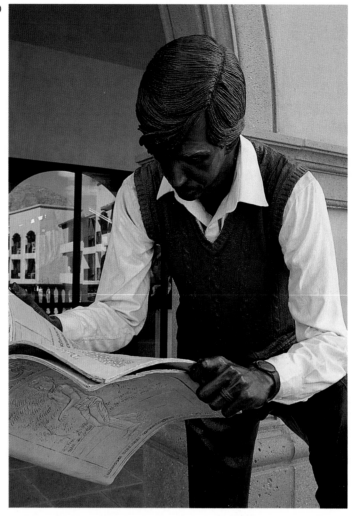

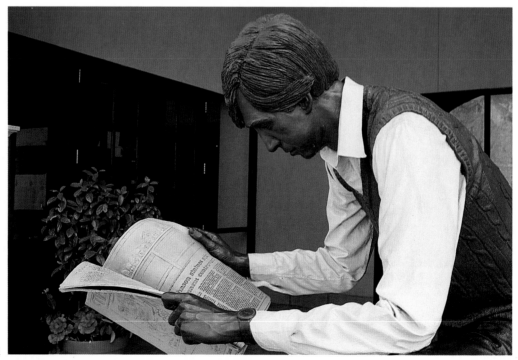

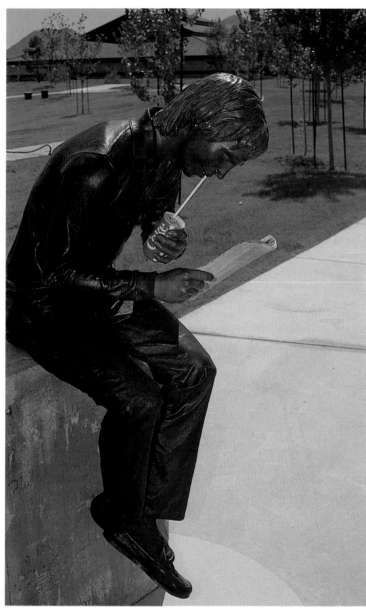

Plates 50 - 51. **POINT OF VIEW.** Installation Westin La Paloma Resort, Tucson, Arizona

Plate 52. **RECESS.** Installation Green Valley, Henderson, Nevada

Plate 53. **THE PAUSE.** Installation Four Seasons Mandalay Hotel, Irving, Texas

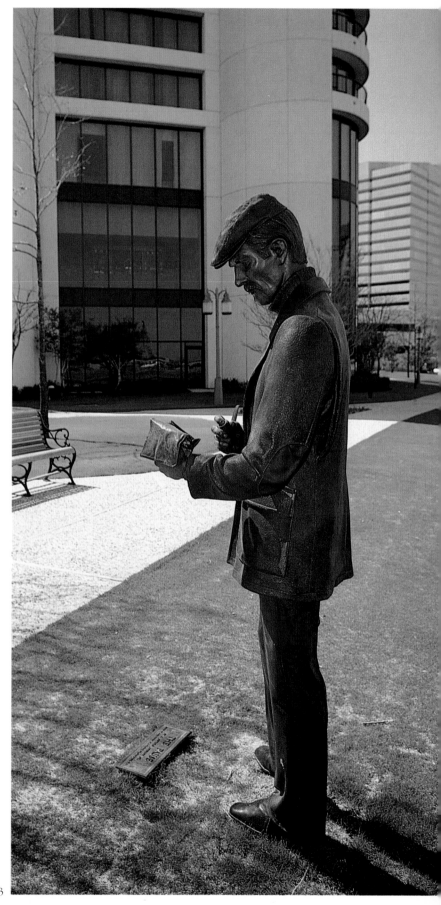

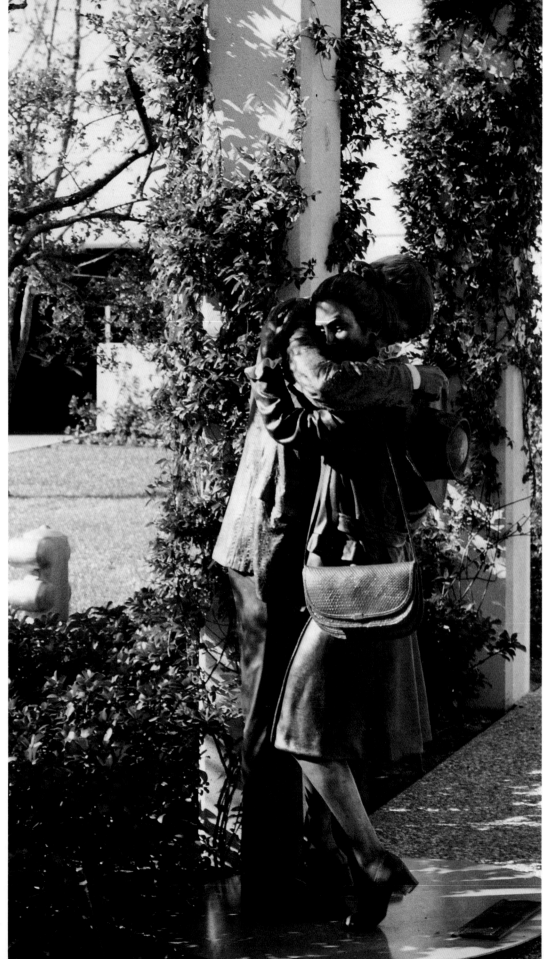

Plate 54. **CONTACT**

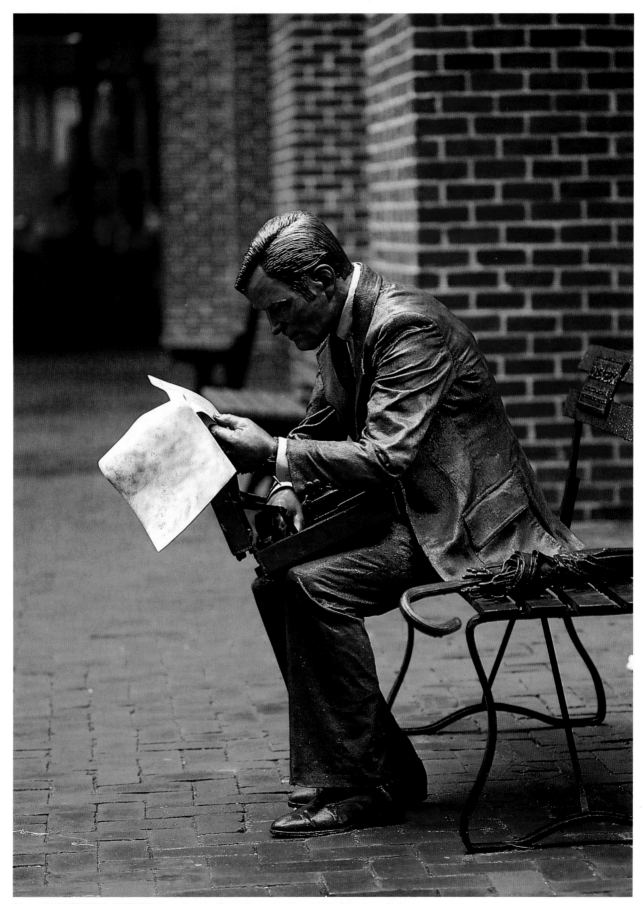

Plate 55. **DOUBLE CHECK.** Installation Four Seasons Hotel, Washington, D.C.

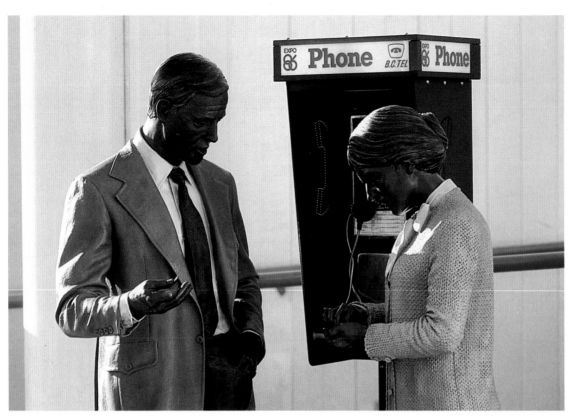

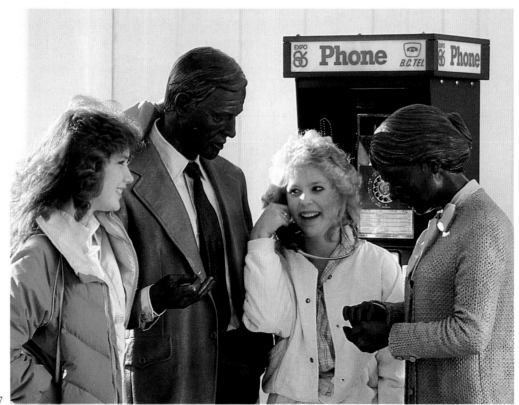

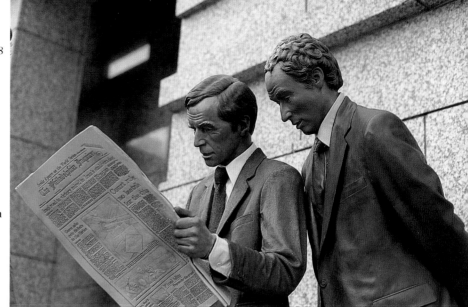

58

Plates 56 - 57. **LONG DISTANCE.**
Installation EXPO '86, Vancouver, British
Columbia

Plates 58 - 59. **SECOND HAND NEWS.**
Installations at the Four Seasons Hotel,
Philadelphia, Pennsylvania (top right)
and in Green Valley, Henderson, Nevada
(bottom right)

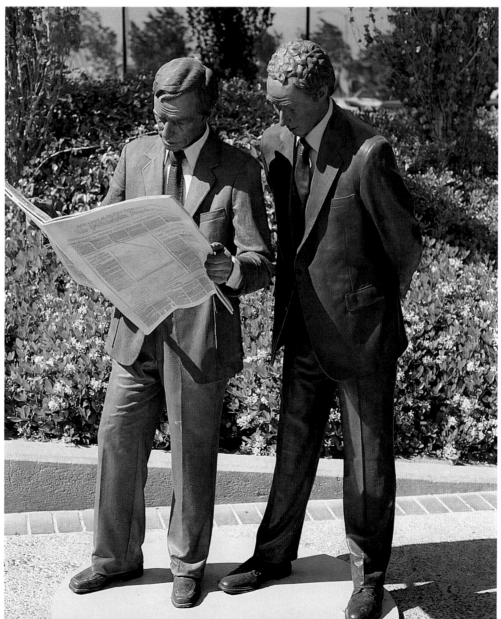

59

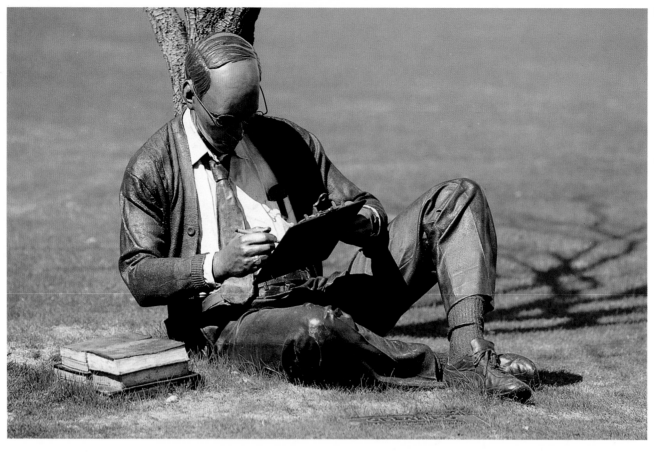

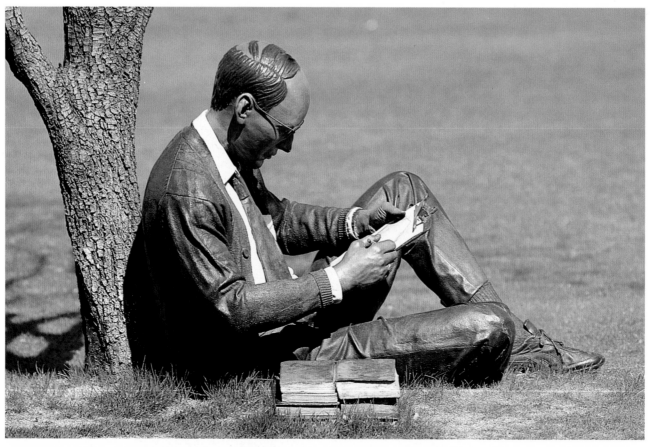

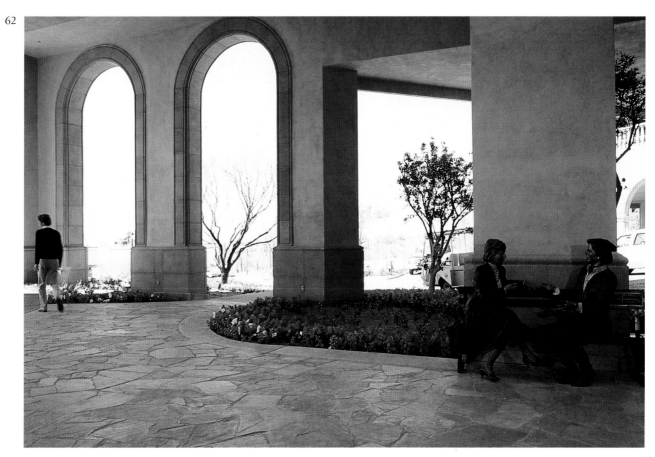

Plates 60 - 61. **CREATING.** Collection Hofstra University, Hempstead, New York

Plates 62 - 63. **CHANCE MEETING.** Installation Westin La Paloma, Tucson, Arizona

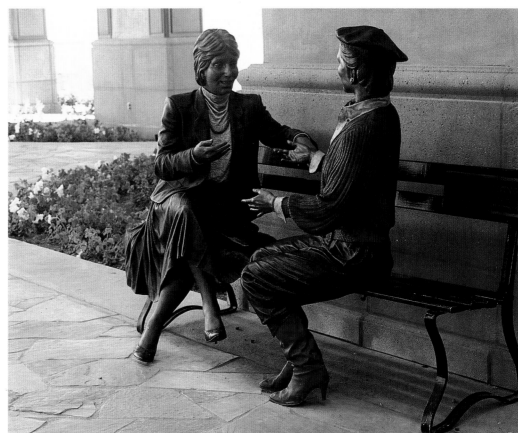

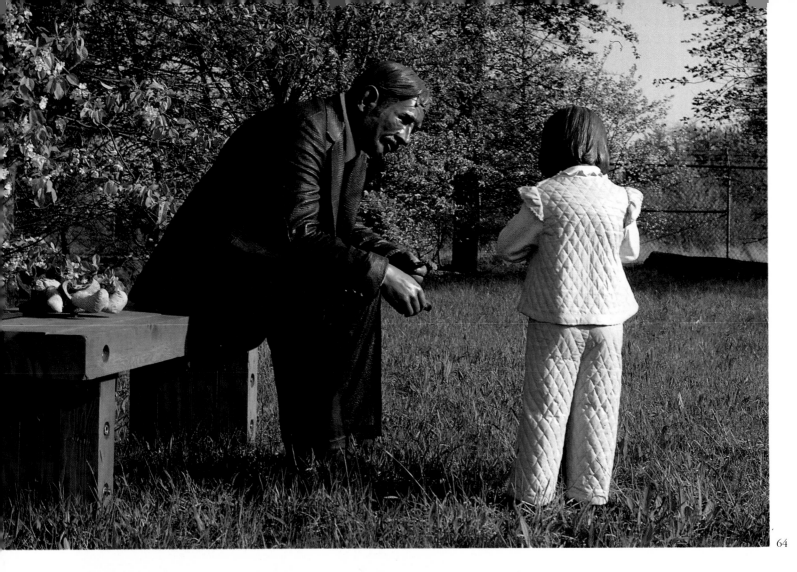

64

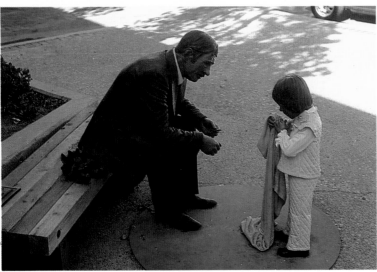

65

Plates 64 - 65. **GENERATION BRIDGE.** Collection American Nevada Corporation, Henderson, Nevada

Plate 66. **ALLOW ME**

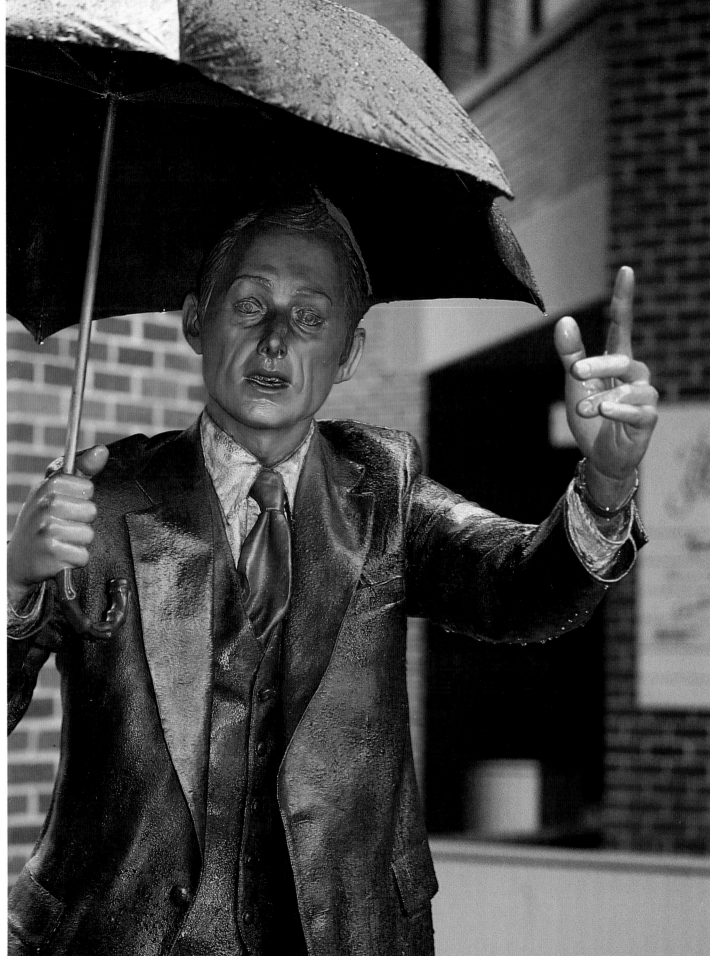

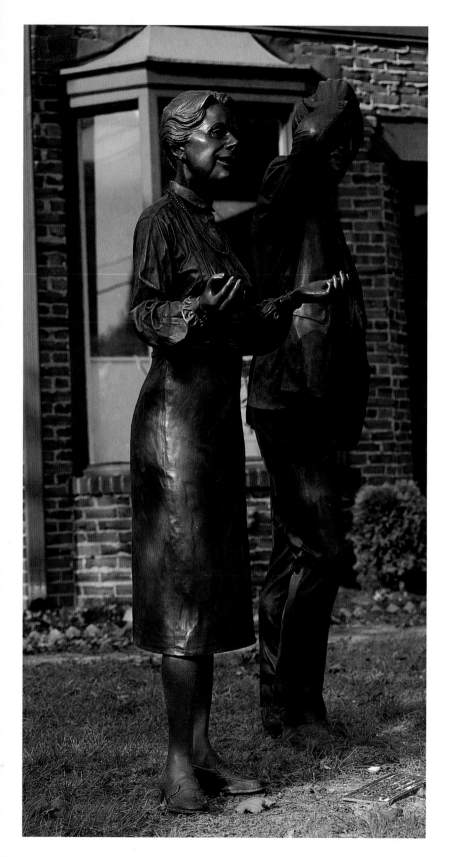

Plates 67 - 68. **COMPREHENSION**
Not pictured here is an additional element: a cast-bronze *Art in America* magazine, placed on an adjoining bench, open to an article entitled "The Resurgence of Realism in Sculpture".

The couple is seen examining a sculpture by Ron Klein.

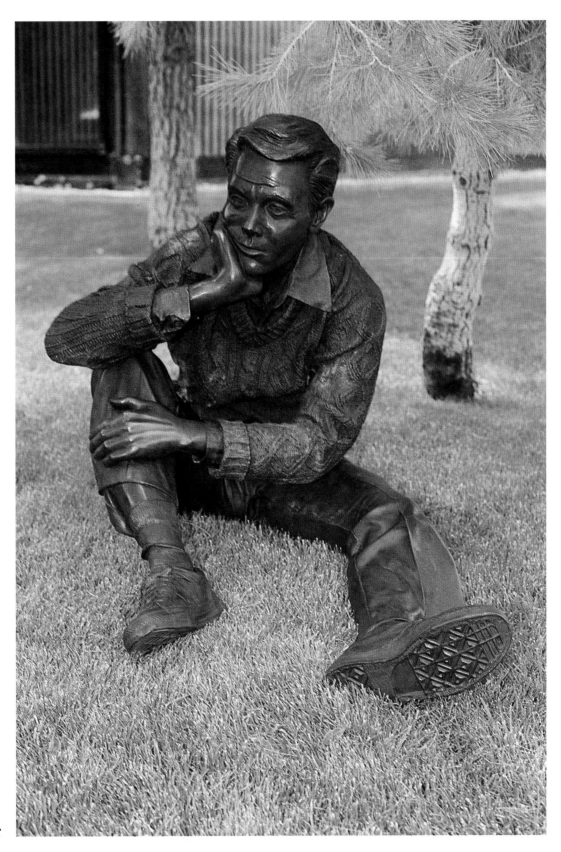

Plate 69. **FAR OUT**

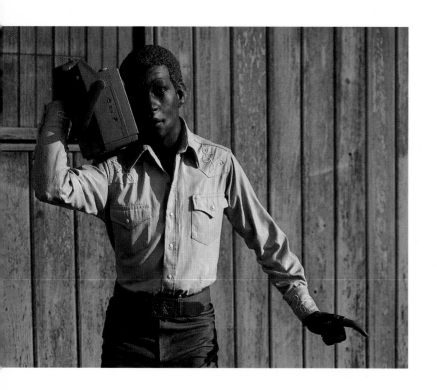

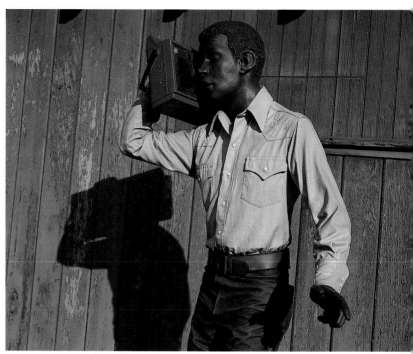

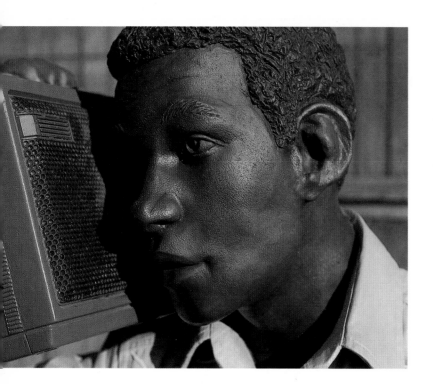

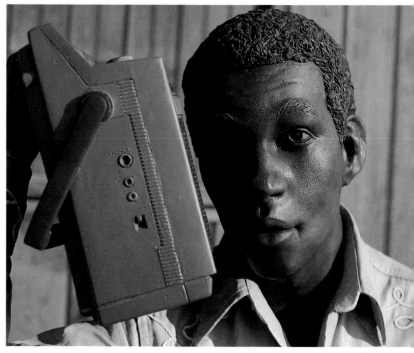

Plates 70 - 73. **GETTING DOWN**

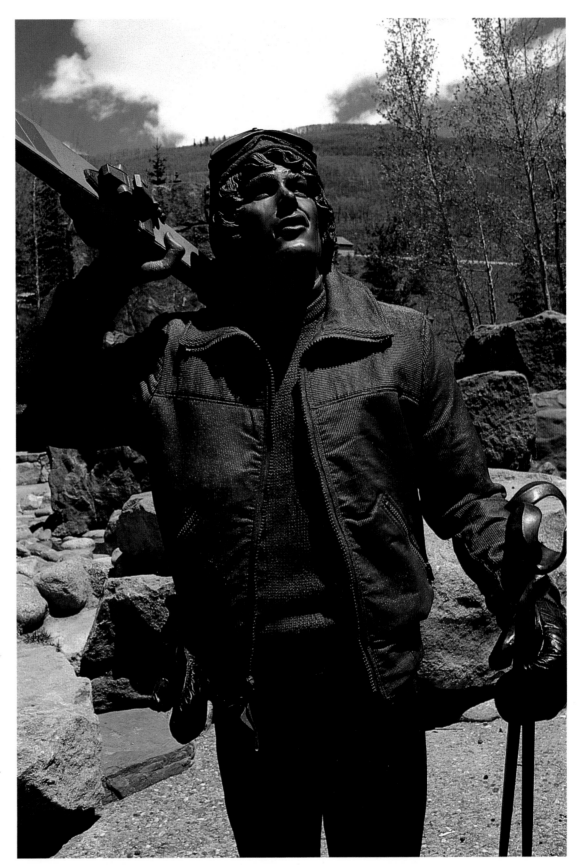

Plate 74. **ANTICIPATION.** Installation Vail, Colorado

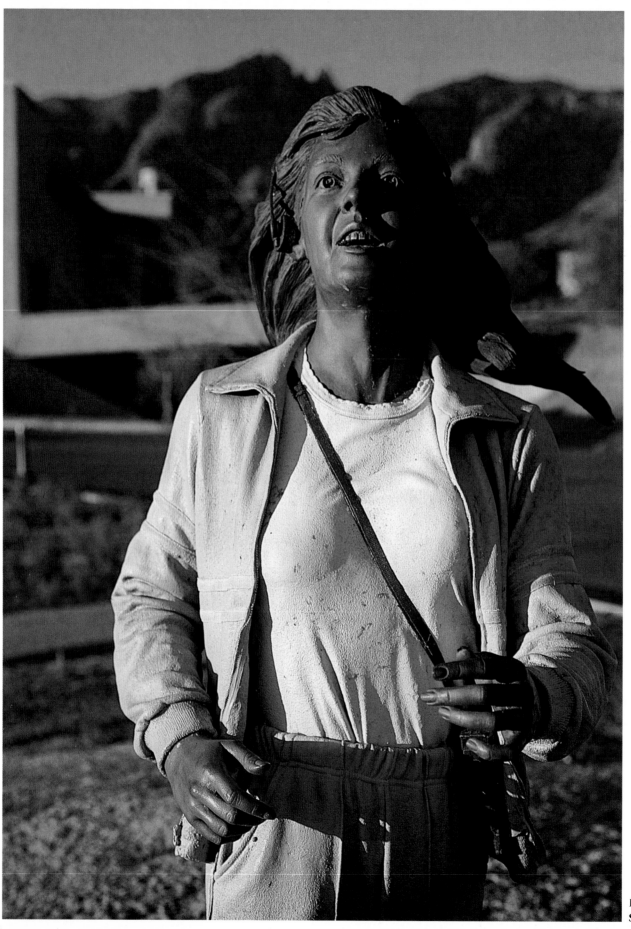

Plate 75.
SHAPING UP

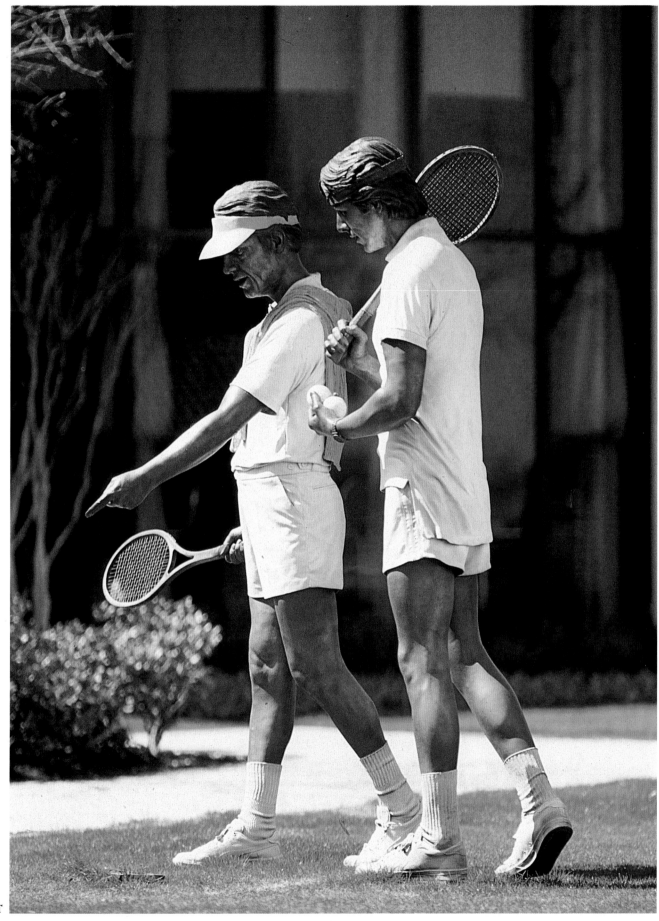

Plate 76.
MATCH POINT

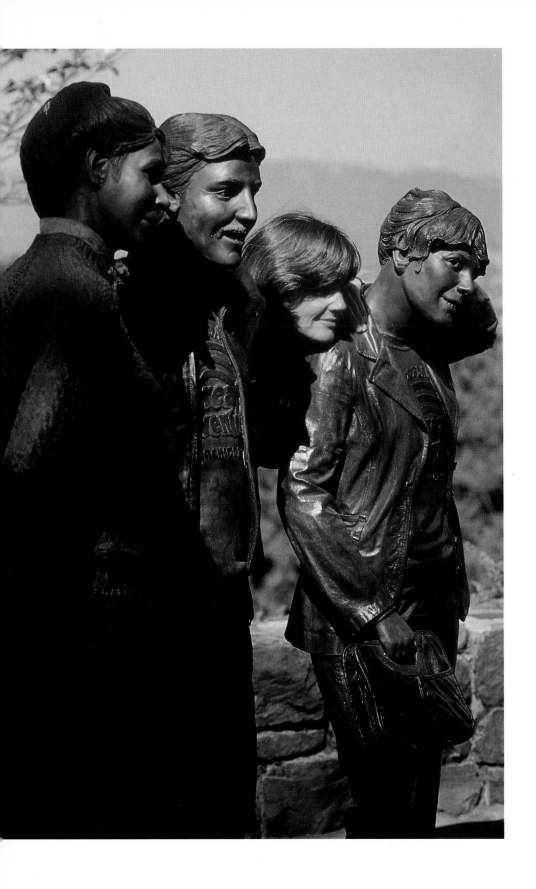

Plates 77 - 80. **PHOTO SESSION.**
Collection Vancouver Museum, Queen
Elizabeth Park, Vancouver, British Columbia

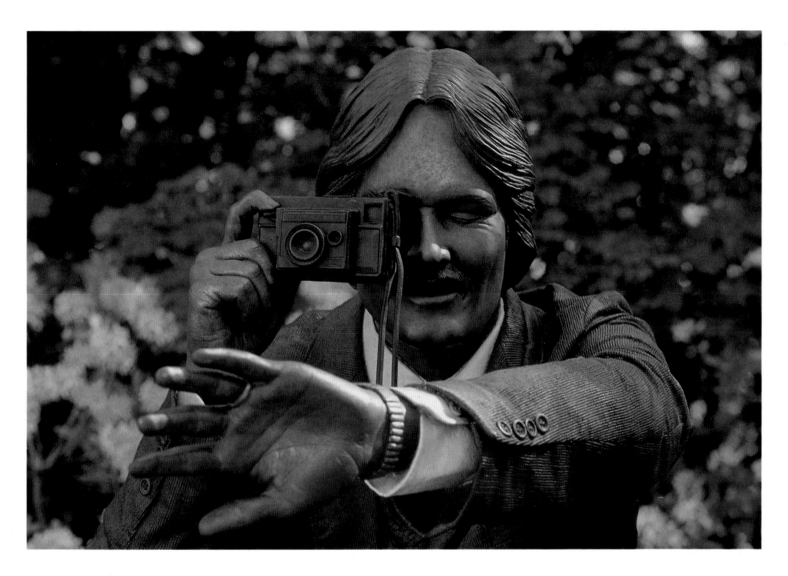

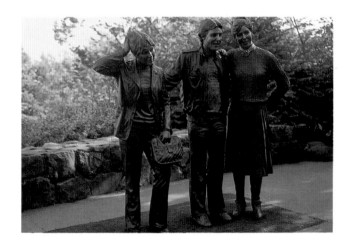

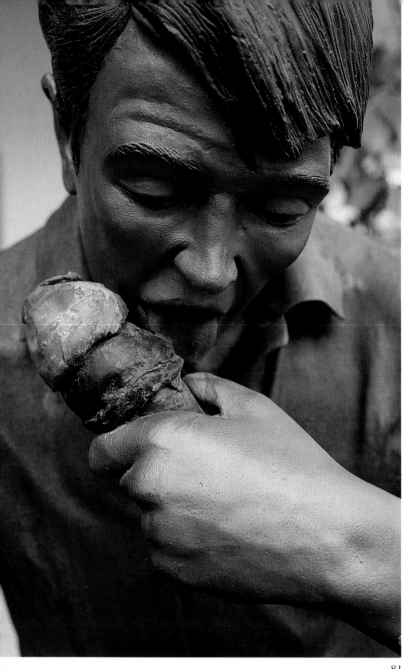

81

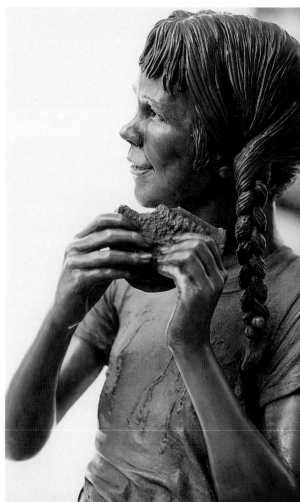

Lifesize and ultrarealistic, J. Seward Johnson's sculptures draw people to them . . . You want to touch a J. Seward Johnson Sculpture. You want to talk to it. Kids want to climb on it or snuggle up with it. Johnson says he wants to remind us of the warmth of spirit. He wants people to get involved with them.
Kem Sawyer, *The Hill Rag*, May 17, 1985

82

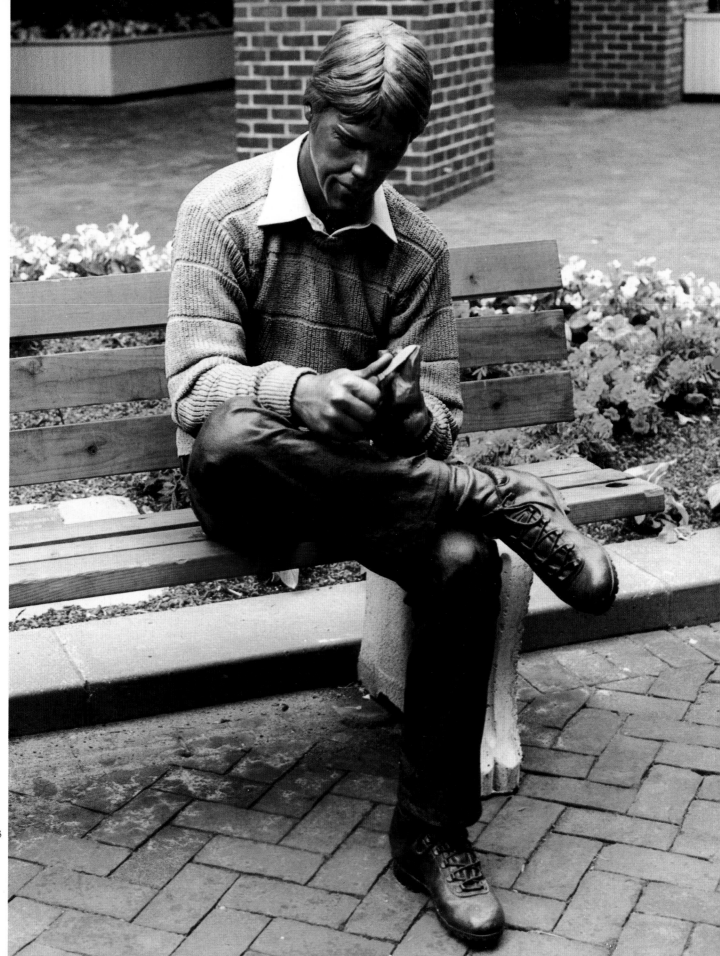

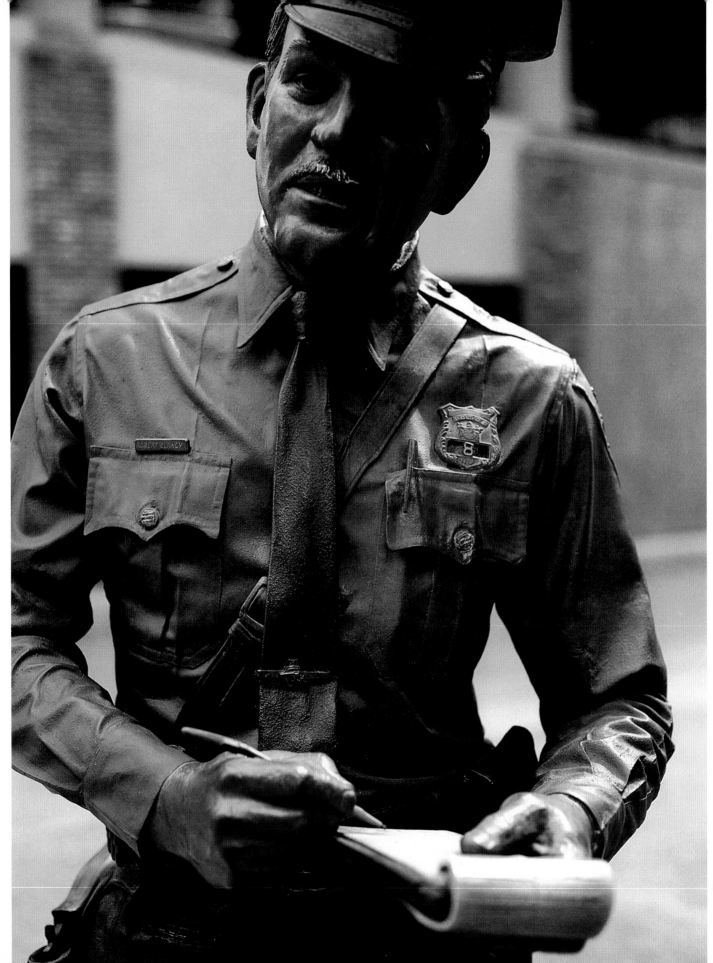

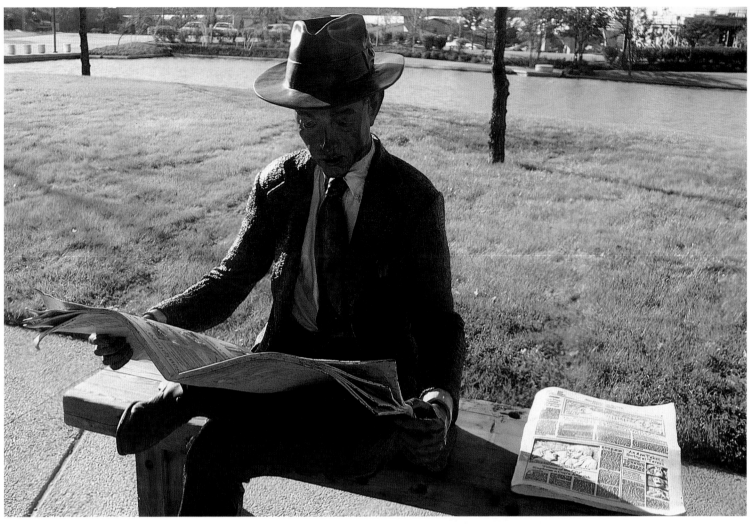

85

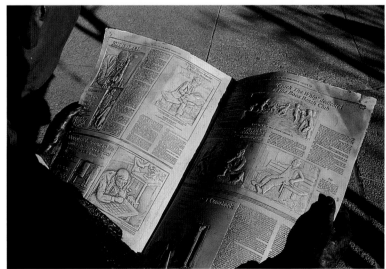

Plate 84. **TIME'S UP.** Collection New Orlean's Energy
Center, New Orleans, Louisiana

Plates 85 - 86. **THE NEWSPAPER READER**

86

There is sincerity and joie de vivre in these figures caught in the midst of daily tasks. By pursuing realism, yet never resorting to saccharine artifice, {Johnson} has breathed life and quiet humor into these works.
Barbara DeGroot, *Las Vegas Weekend*, November 9, 1984

Plates 87 - 89. **SO THE BISHOP SAYS TO THE ACTRESS . . .**

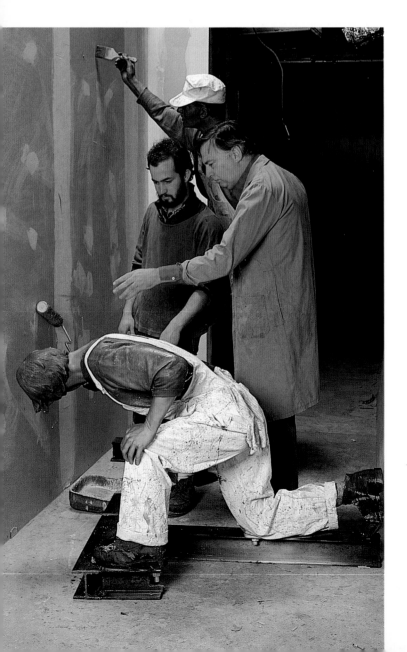

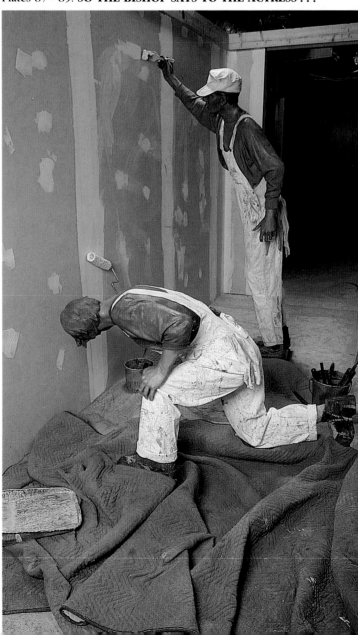

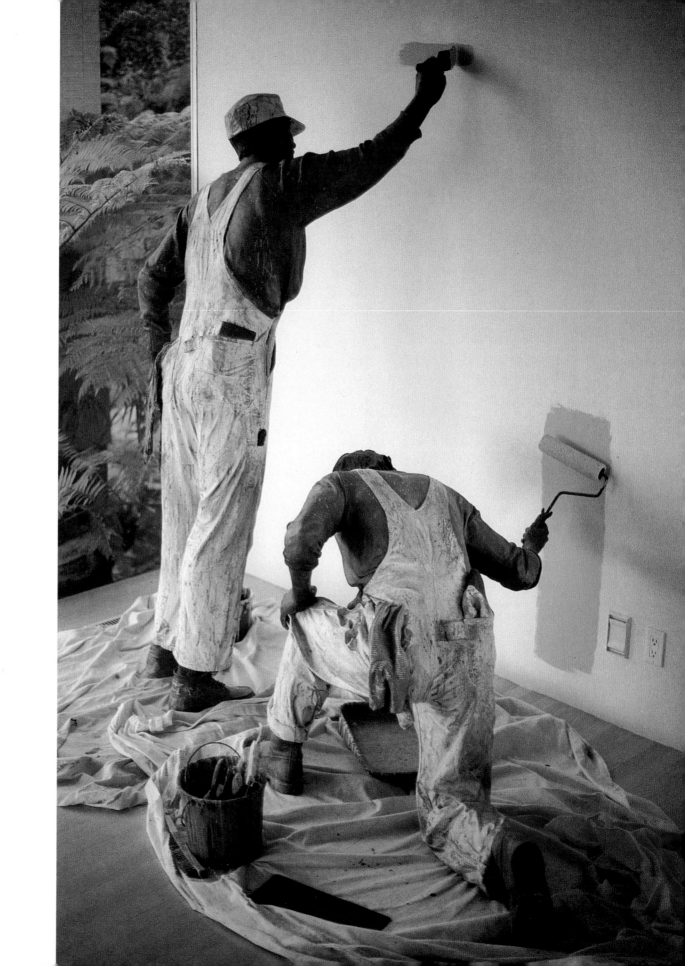

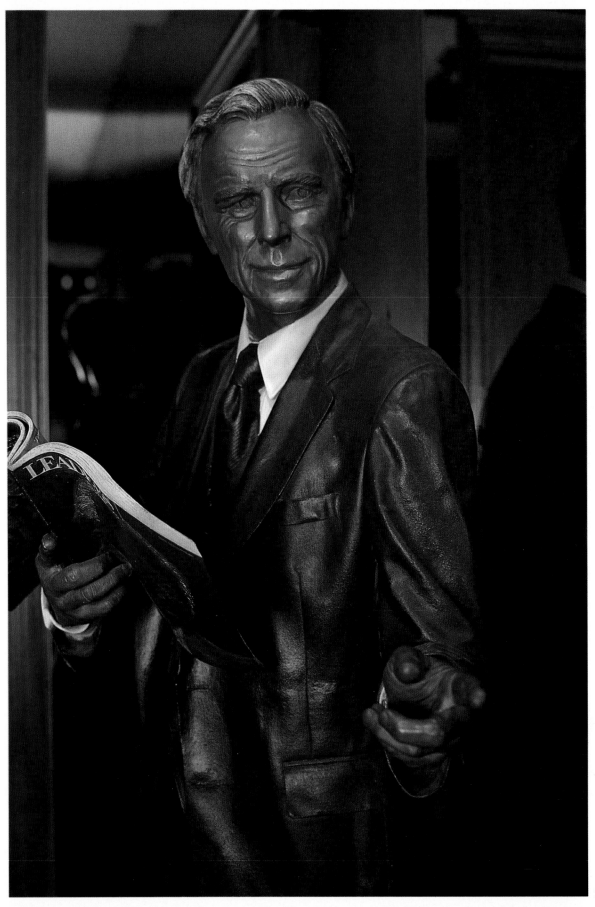

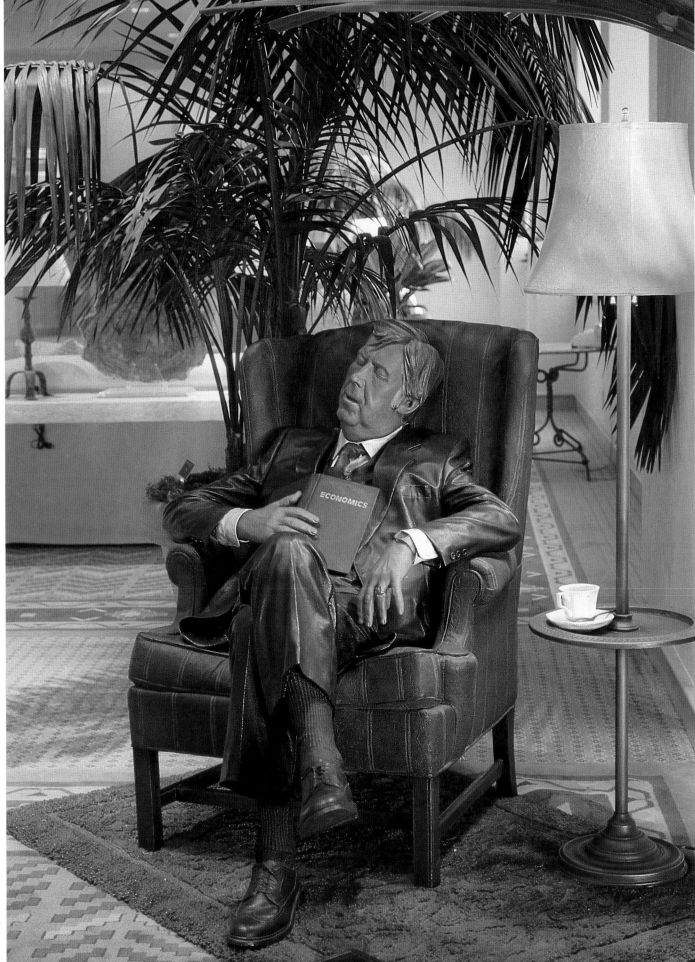

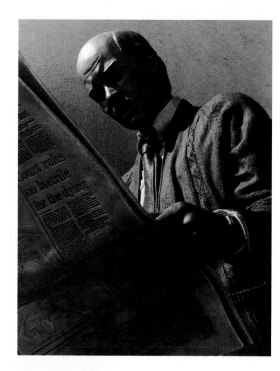

Plate 90. **THAT A WAY.** Collection *Leaders Magazine,* New York City

Plate 91. **AFTER LUNCH**

Plates 92 - 94. **CATCHING UP.** Collection The Crow-Terwilliger Company, Atlanta, Georgia

Plate 95. **HOLIER THAN THOU**

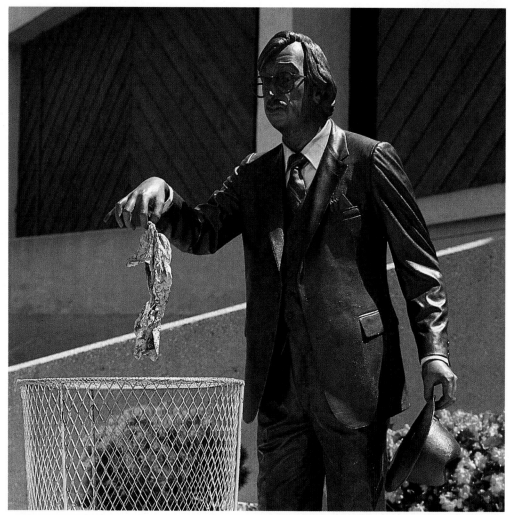

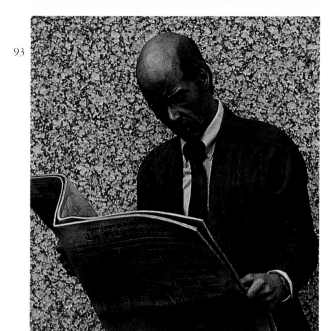

93

94

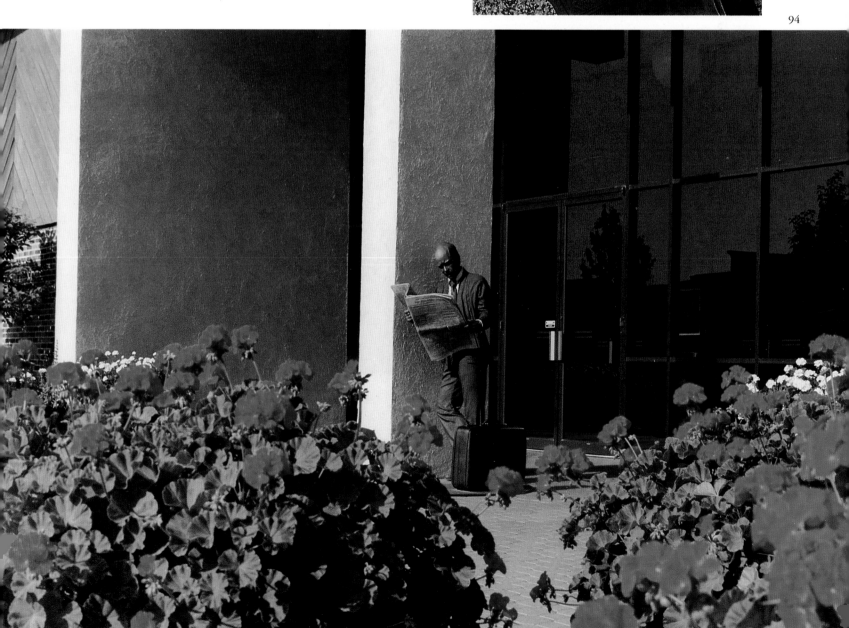

Plate 96. **A LITTLE TO THE RIGHT**

Plate 97. **AT LONG LAST**

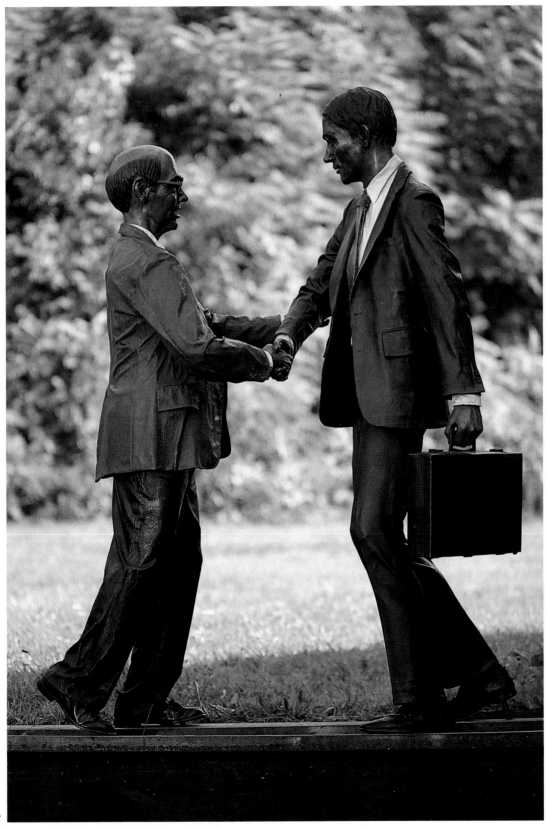

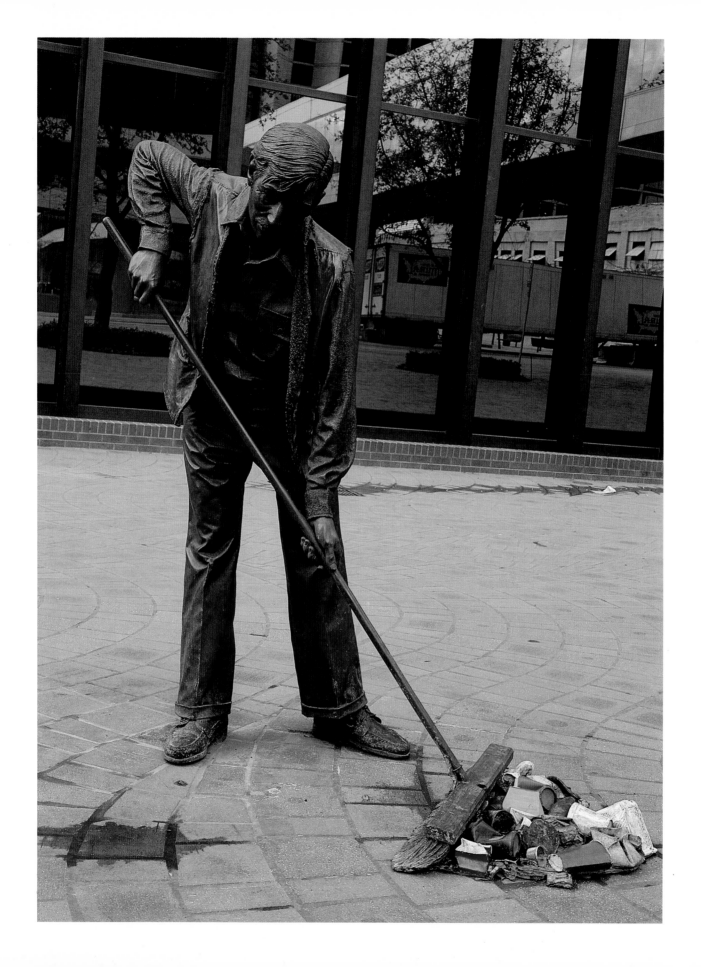

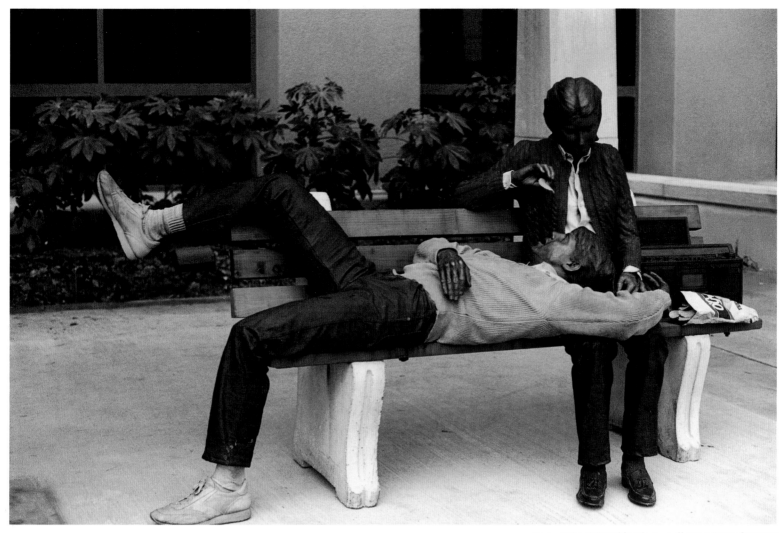

Plate 100. **COURTING.** Installation Four Seasons
Hotel, Austin, Texas

Plates 98 - 99. **AFTERMATH.** Collection Trammell
Crow Company, Dallas, Texas

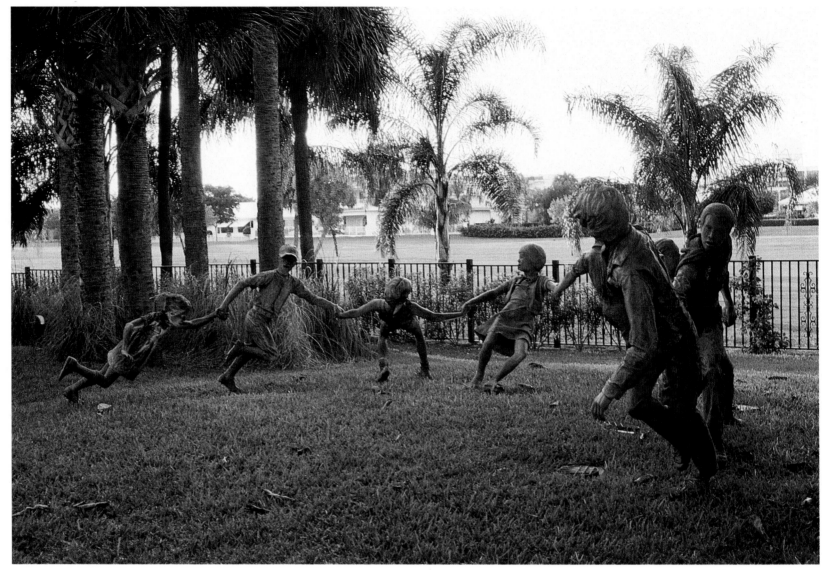

101

Plates 101 - 104. **CRACK THE WHIP**
(Overleaf) Viewed at sunrise, Boca Raton Hotel & Beach
Club, Boca Raton, Florida

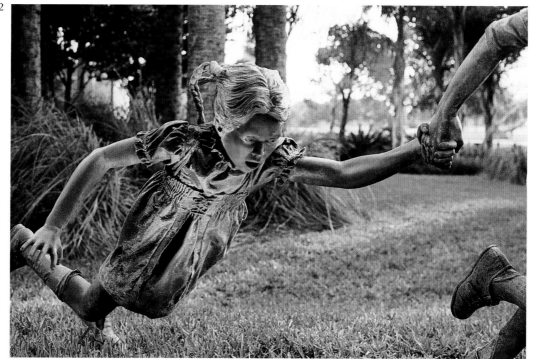

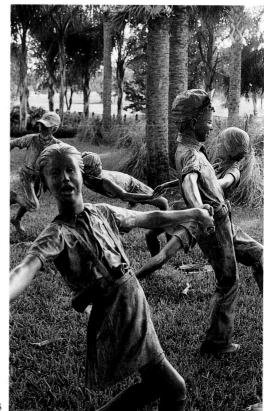

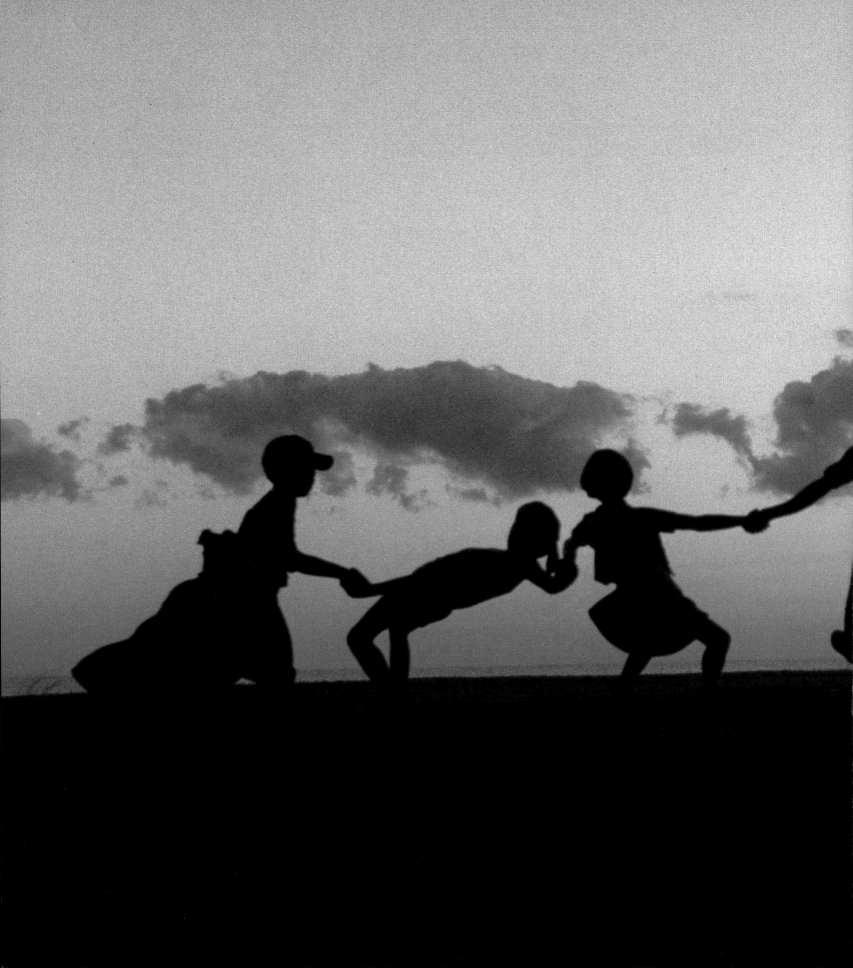

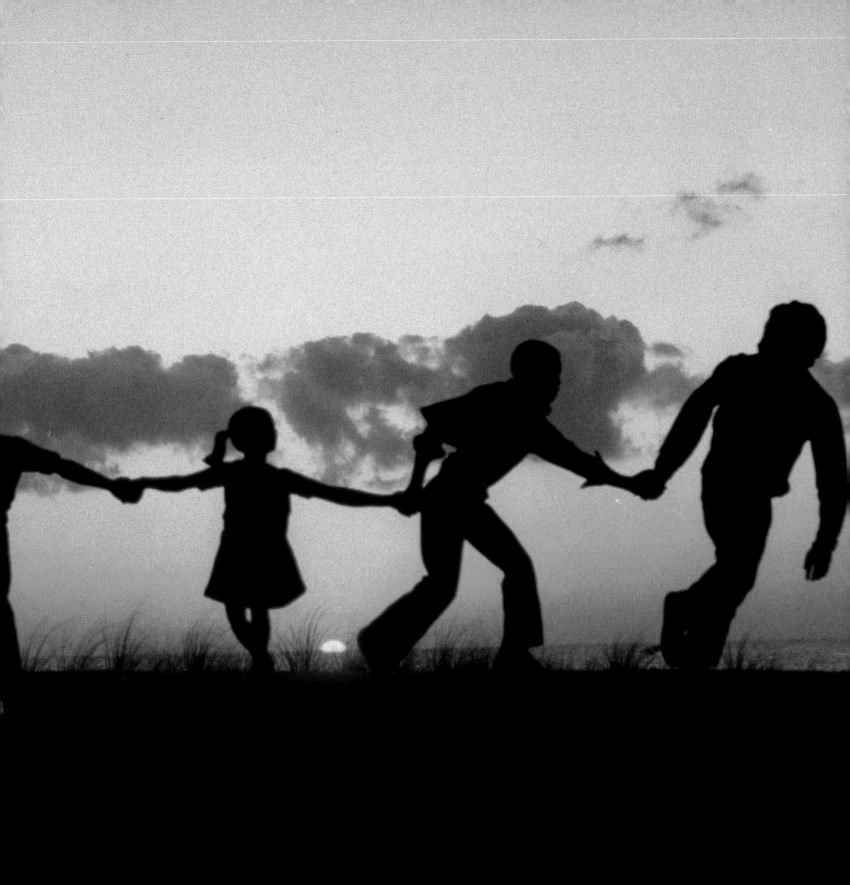

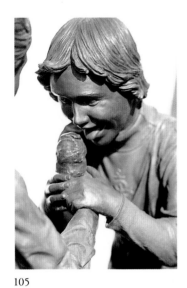

105

Plates 105 - 106. **JUST A TASTE.** Collection The Webb Companies, Lexington, Kentucky

Plate 107. **LUNCHBREAK.** Installation Knoxville World's Fair, Knoxville,Tennessee; collections Trane Corporation, Cincinnati, Ohio, and The Morris Museum of Arts and Sciences, Morristown, New Jersey

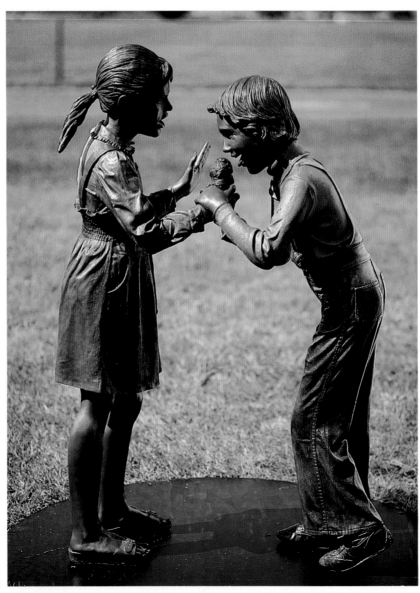

106

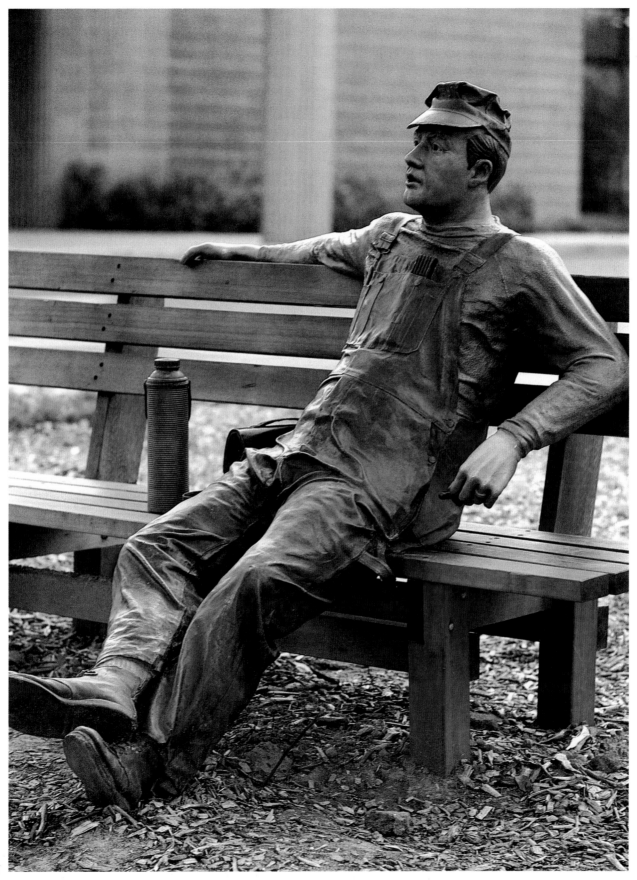

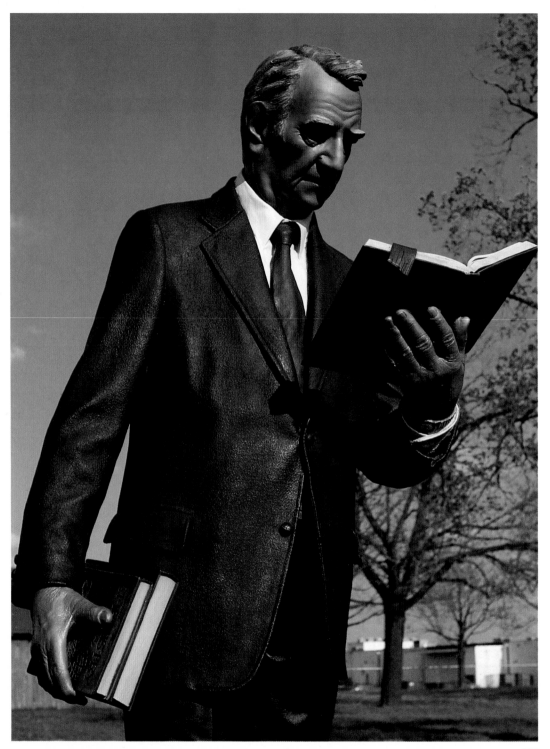

108

Plate 108. **THE STROLLING PROFESSOR.** Collection
North Carolina State University, Raleigh, North Carolina

Plate 109. **ON THE BENCH.** Collection The State of New Jersey

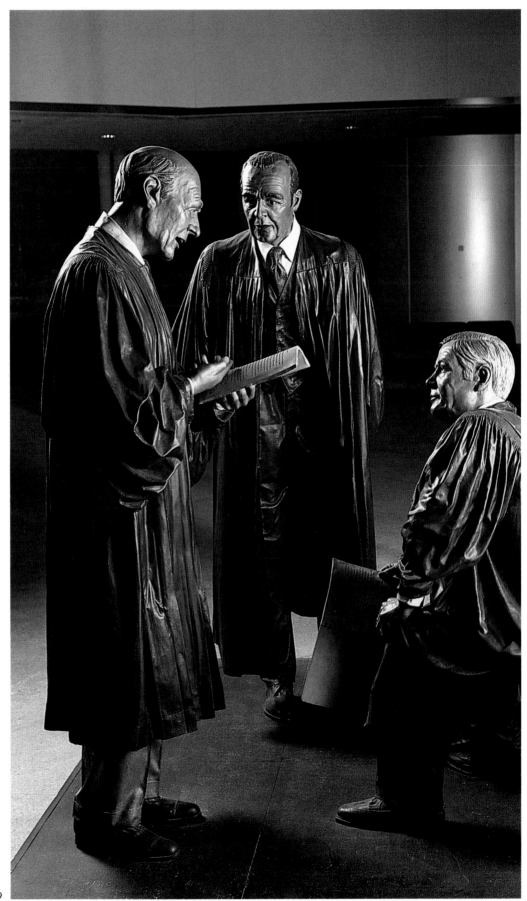

110

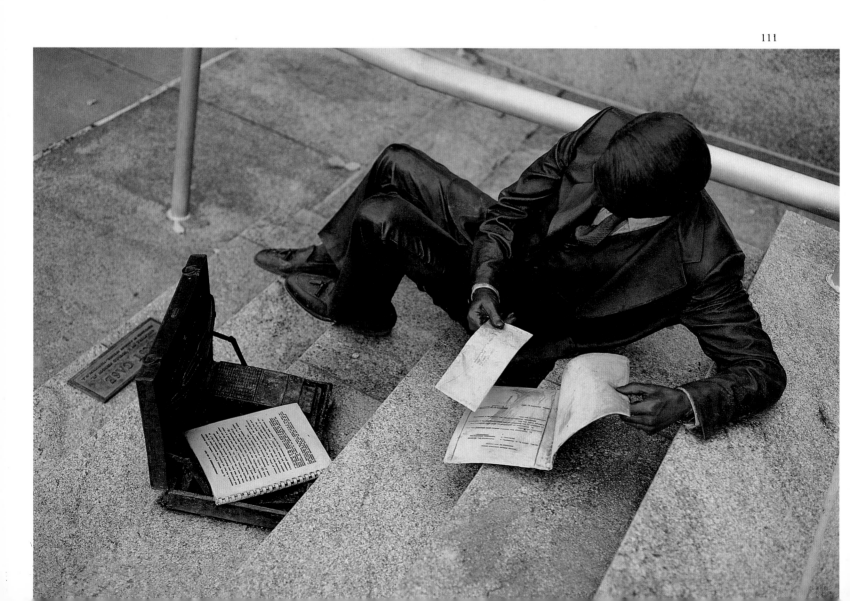

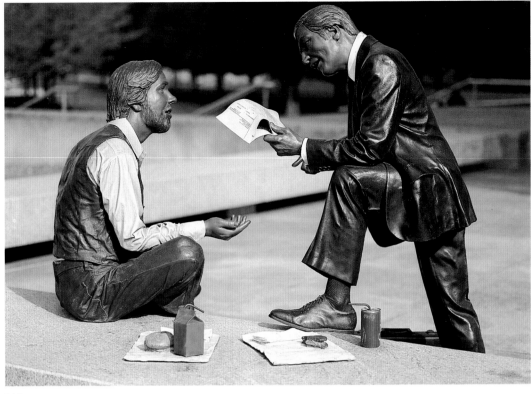

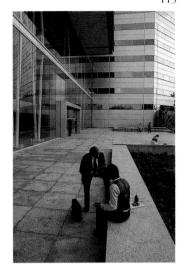

113

114

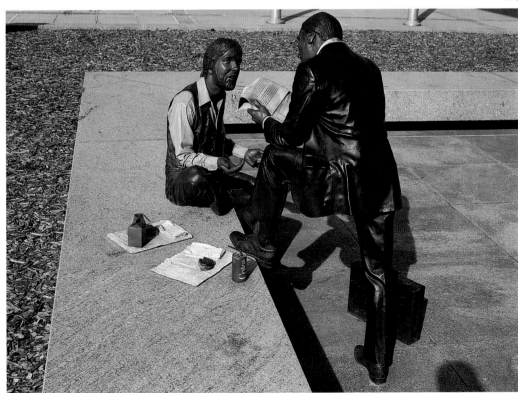

Plates 110 - 111. **FIRST CASE.**
Plates 112 - 114. **THE BRIEFING.**
Collection The State of New Jersey;
installation The Richard J. Hughes
Justice Complex, Trenton, New Jersey

112

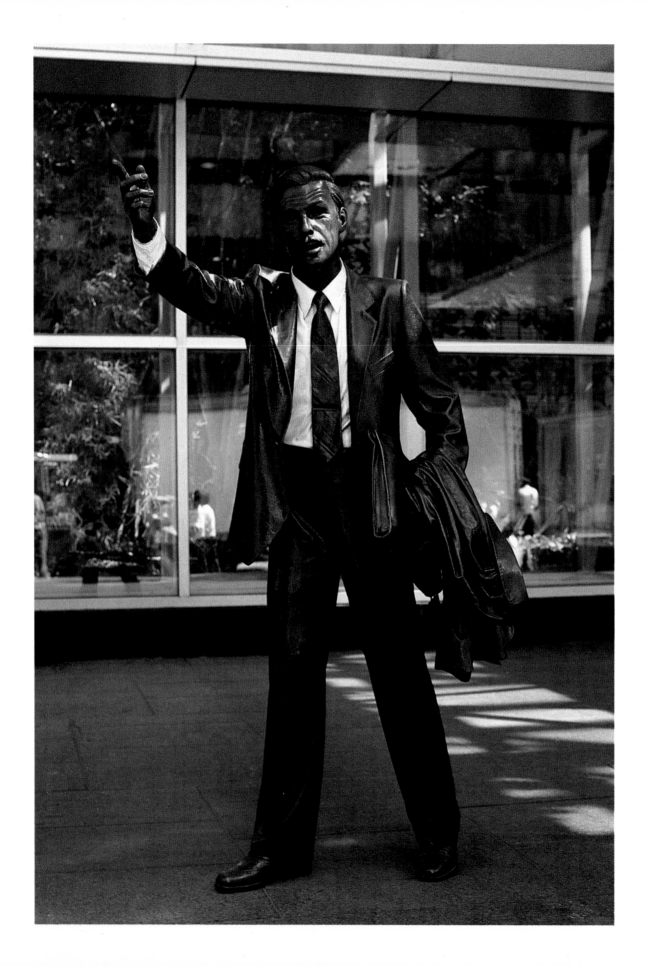

Plates 115 - 116. **TAXI!** A unique commission for Chemical
Bank World Headquarters, New York City

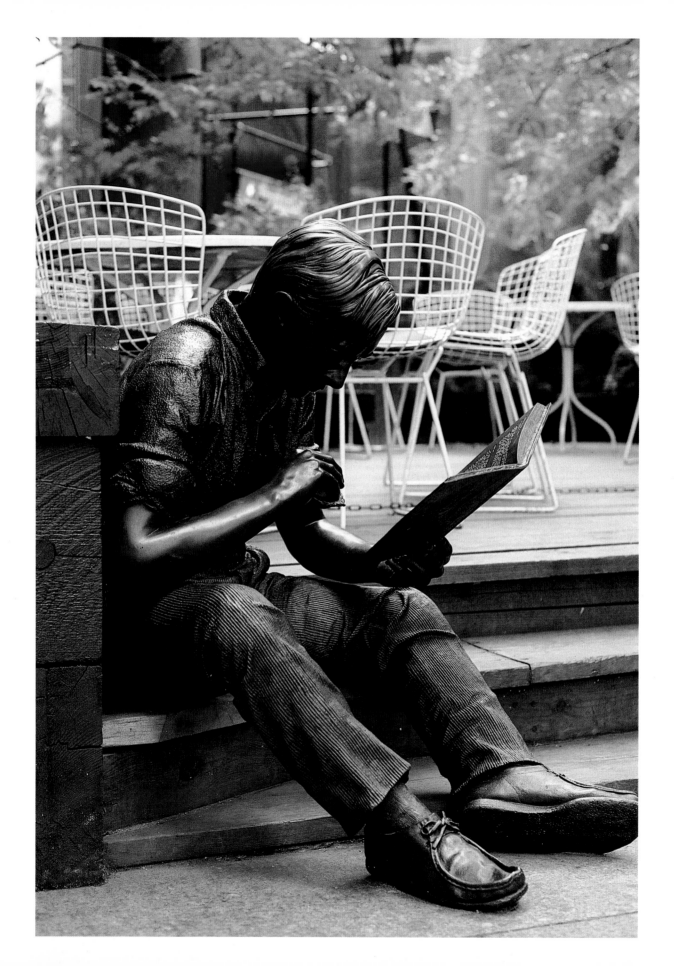

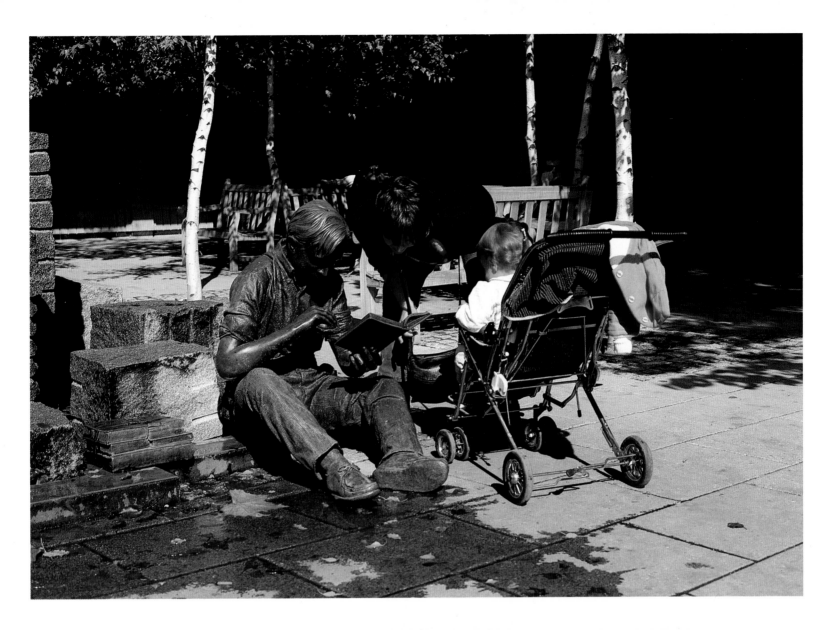

Plates 117 - 119. **OUT TO LUNCH.** Collection Collins
Development, Palmer Square, Princeton, New Jersey (above).
On loan to Rockefeller Center's Exxon Park, New York City
(left)

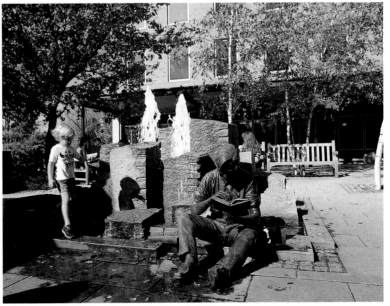

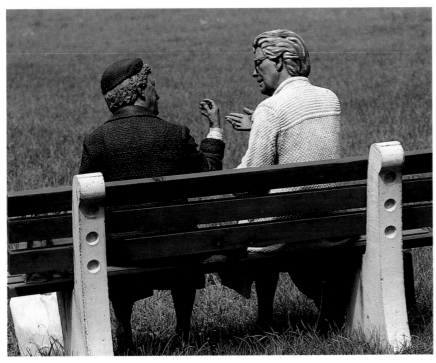

121

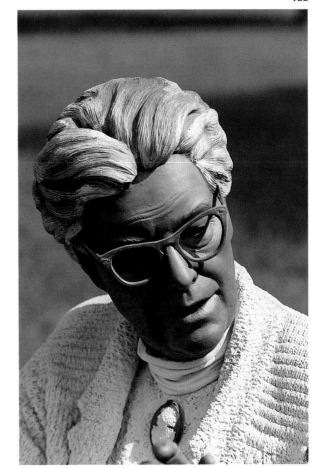

122

123

Plates 120 - 123. **CROSSING PATHS**
Plates 124 - 126. **BETWEEN APPOINTMENTS**

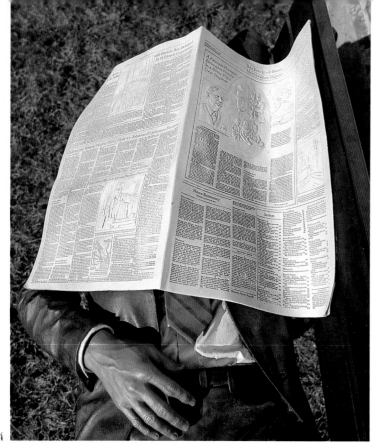

124

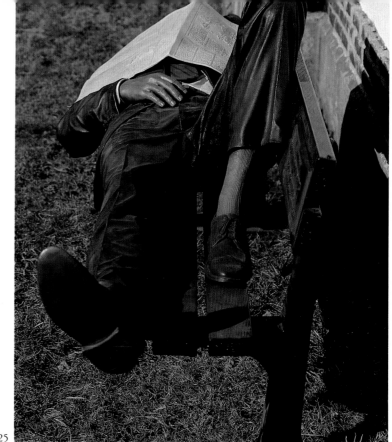

125

126

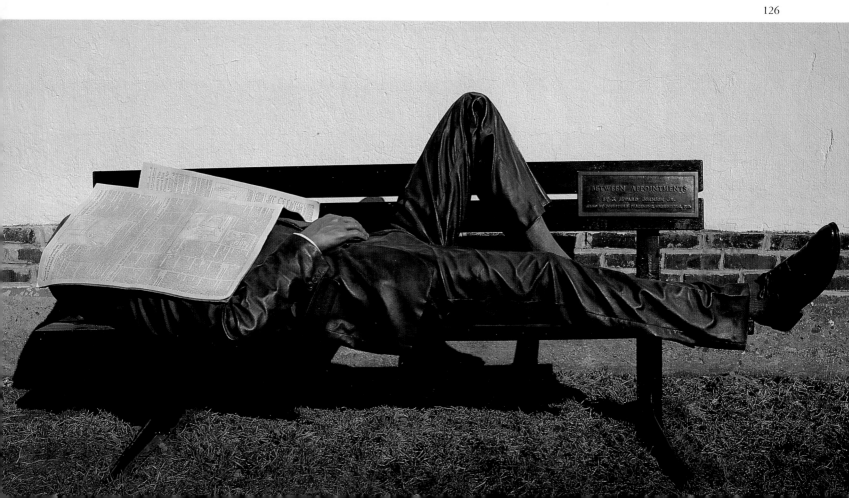

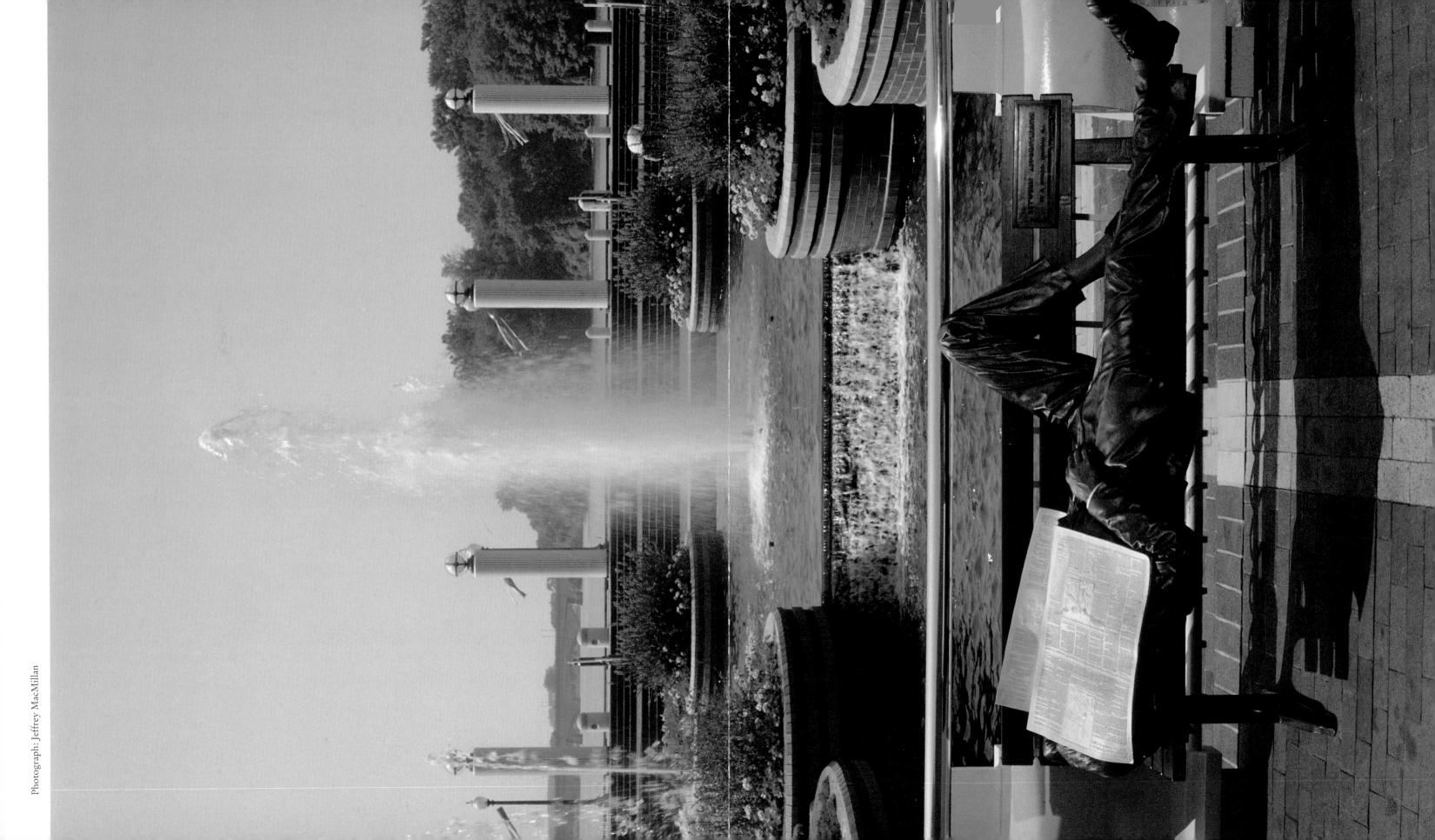

THE MAKING OF A SEWARD JOHNSON SCULPTURE

J. Seward Johnson, Jr., uses a maquette (small clay model) to fashion the gesture and pose of a figure, which will take up to two years to reach completion.

Once the pose is final and the age, narrative, and facial expression are established, the artist selects a live model to come to the studio to pose. Apprentices at the foundry enlarge the maquette to a life-size nude clay and plastecine figure. Johnson then poses the live model and sculpts the face and exact stance.

After Johnson selects appropriate clothing for the narrative, each item must be disassembled and sewn onto the nude figure, which has been converted to plaster form. Resin is applied to stiffen all the fabrics, and Johnson then arranges the folds into proper motion shapes, pumping air into folds and pockets for a lifelike quality. The sculpture dries for two days and is then carved into sections.

The true foundry process now begins. The pieces are transferred from plaster to wax by making a rubber mold of each plaster section.

The wax is carefully chased, that is, all imperfections are corrected using tools similar in their precision to dentist drills. The wax is then given a ceramic shell by a repetitive dipping into a slurry solution. This slurry is made of increasingly fine grains of silica flours and an aqueous silica solution that hardens in layers. The wax is then burned out at high temperature, leaving only the ceramic shell with a precise image of the original, formed by the silica layers. This is called the lost-wax method of casting.

The pouring of molten bronze is the next phase of the foundry process. With the bronze reaching a temperature of 2,000° F, it appears almost as poured light. Again, as in the wax stage, extensive chasing assures that all the textural details of the original will be preserved. The pieces are once more joined to form a full figure, and all welds and seams are chased. Items such as pencils and eyeglasses are modeled in bronze and attached to the figure at this time.

The final stage is patination, or the chemical coloring of the surface of the bronze. The unique colors of Seward Johnson's sculpture were developed specifically for his work by the Johnson Atelier. They are a combination of traditional patina chemicals and tinted lacquers. The bronze surface is heated with a hand-held acetylene torch flame, and the specific chemicals are brush applied. The flame then "burns" the chemical color into the bronze. A thin film of incralac, a protective coating, is applied to guard against paint or scratches. The entire sculpture is then waxed, as an additional protection from climatic changes. The Johnson sculpture is now complete.

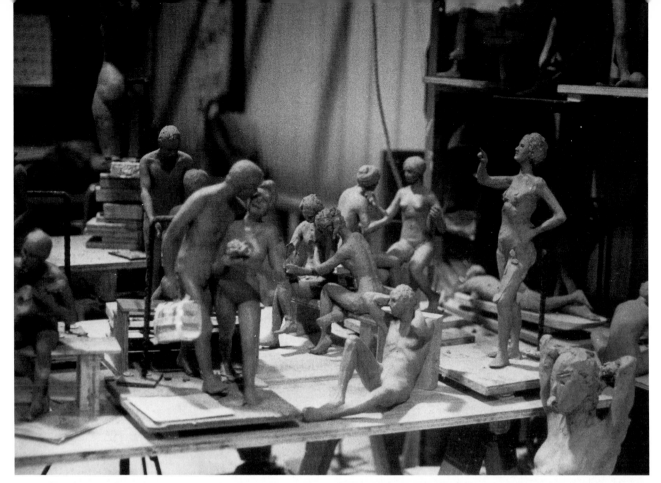

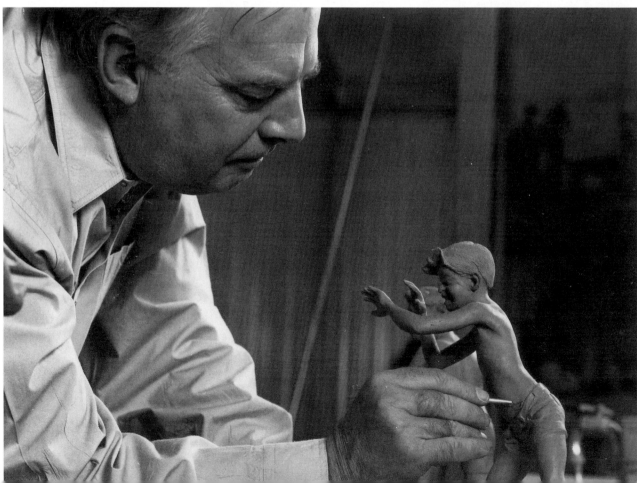

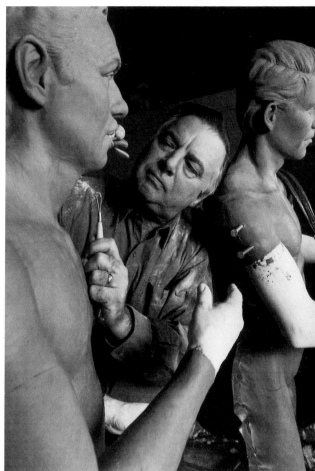

Johnson sculpting from life (above),
Johnson and maquettes (opposite page)

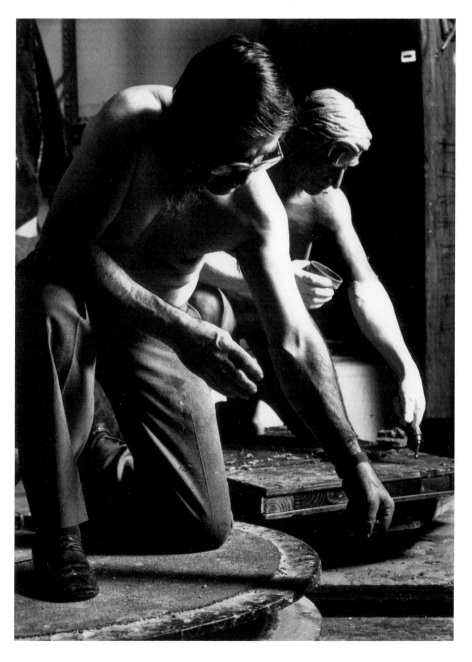

123

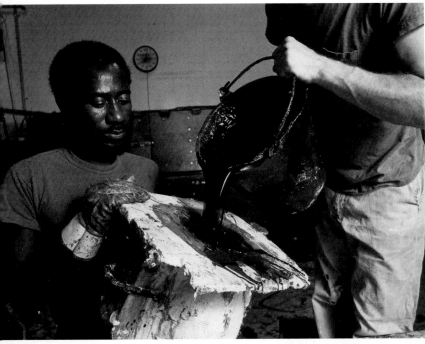

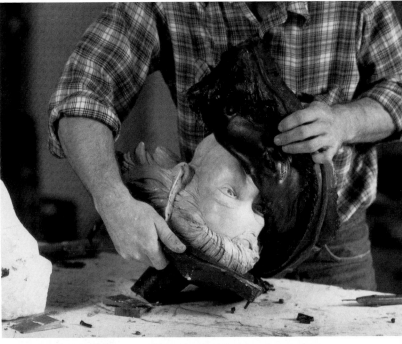

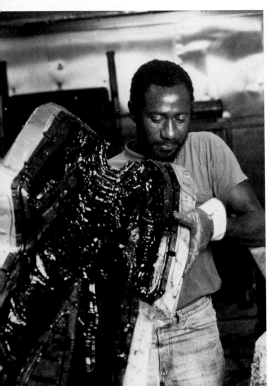

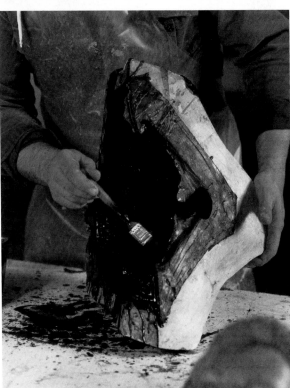

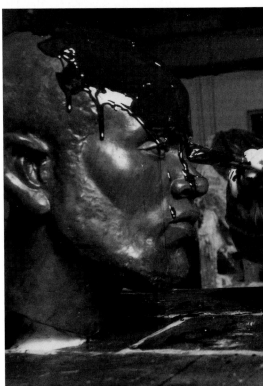

Rubber mold making (above), wax chasing process (right), slurry process (far right)

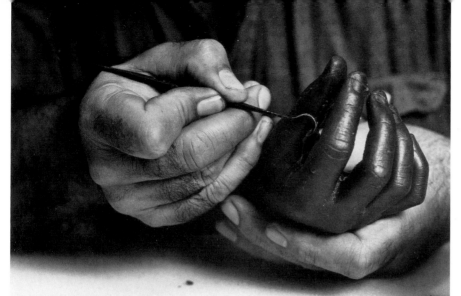

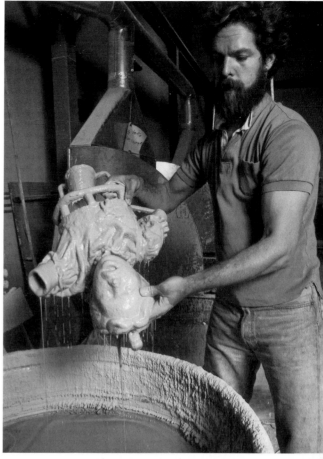

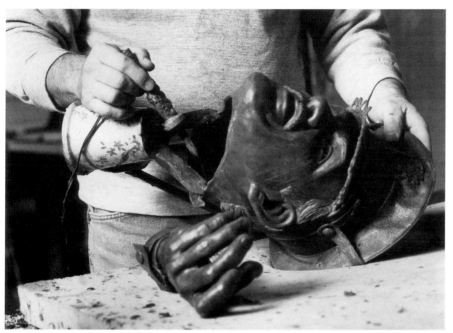

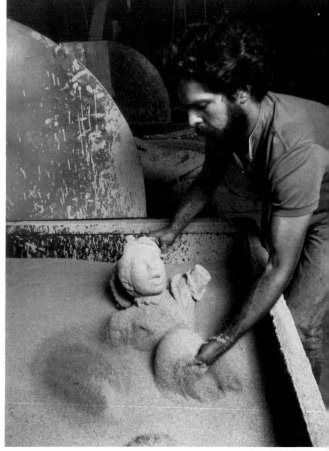

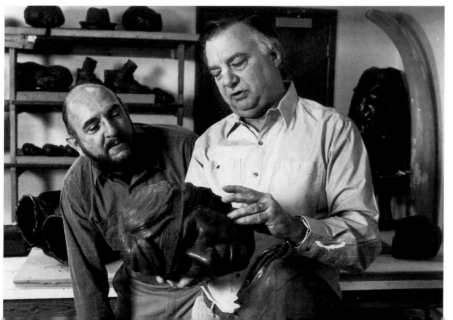

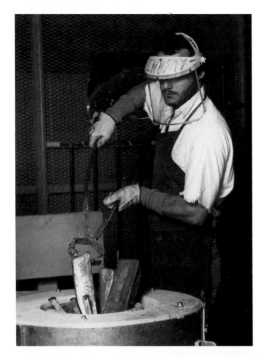

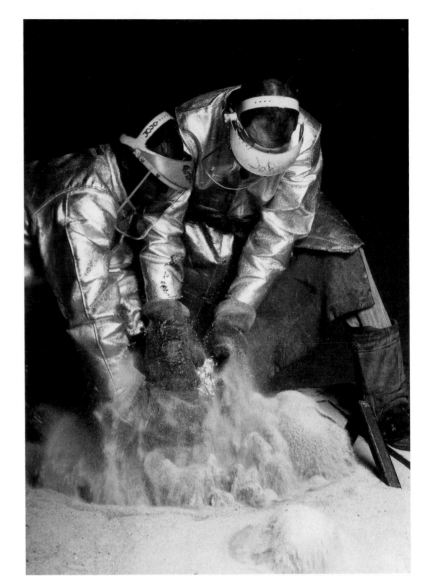

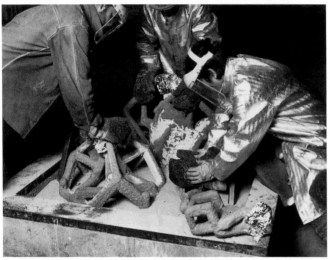

The casting process

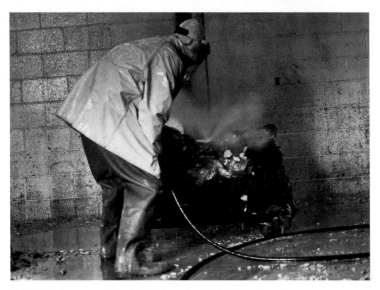

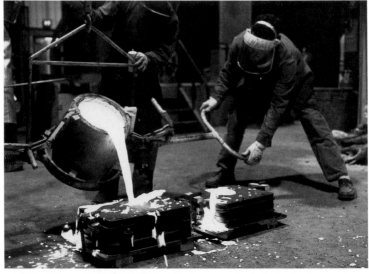

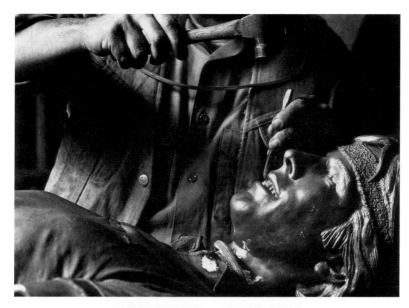
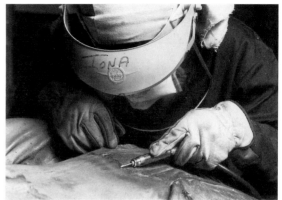
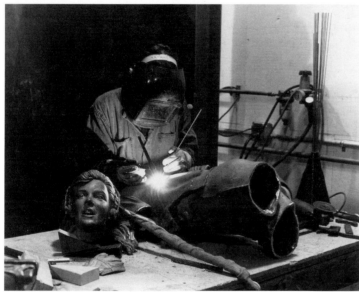

Welding and metal chasing

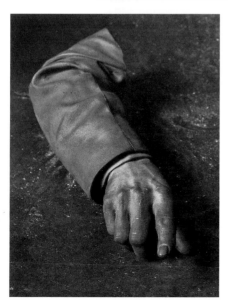
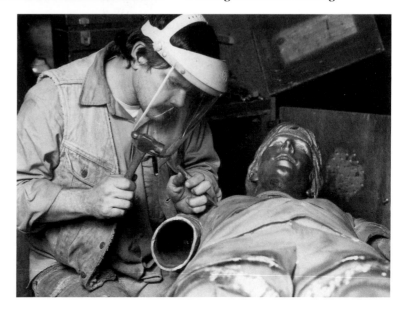

A COMPLETE CATALOG OF SCULPTURES FROM 1968 TO 1987

All works are life-size and cast in bronze, unless otherwise noted. Bold numbers correspond to color-plate numbers. Italic numbers refer to pages containing black-and-white photographs. Works not illustrated herein are indicated by an asterisk (*).

ADVENTURE, 1979
131

AFTER LUNCH, 1985
42, **91**

AFTERMATH, 1984
98–99

A LITTLE TO THE RIGHT, 1984
96

ALLOW ME, 1984
44, 55 (detail), **66**

ANTICIPATION, 1984
74

APRES SKI, 1987
131

ARIEL, 1984
Stainless steel
128

AT LONG LAST, 1983
97

THE AWAKENING, 1980
Aluminum
70 by 17 feet
13–17, *32–33*

BETWEEN APPOINTMENTS, 1987
124–126

BIG SISTER, 1987
130

THE BRIEFING, 1982
34, 112–114

CHRIST

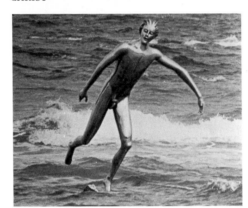
ARIEL

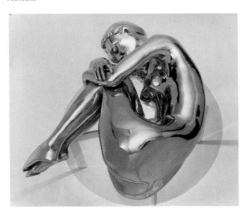
STAINLESS GIRL

LOVE SONG

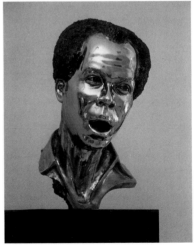
DAVID ARNOLD: A SILVER VOICE

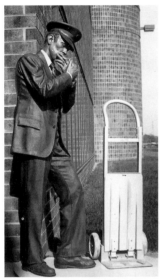 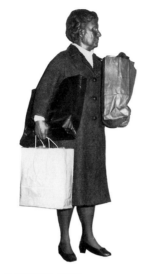 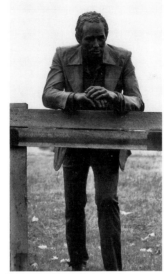 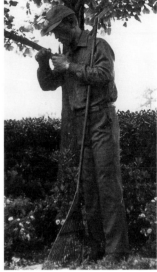

TAKING A BREAK: SKYCAP HOLDING OUT TAKING STOCK FALL

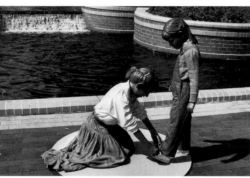
BIG SISTER

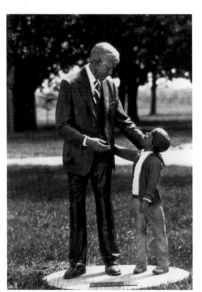
SUNDAY WALK

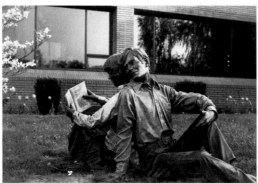
SYMBIOSIS

CURIOSITY

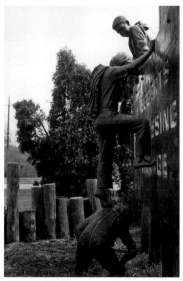

ADVENTURE

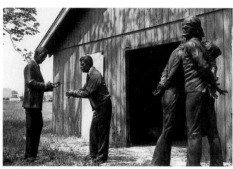

HOSTAGE OBSERVERS

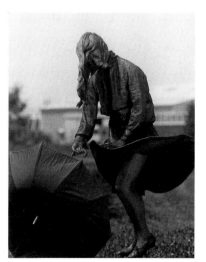

STORMY WEATHER

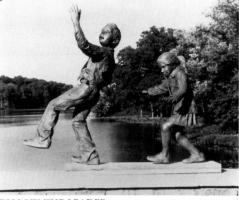

FOLLOW THE LEADER

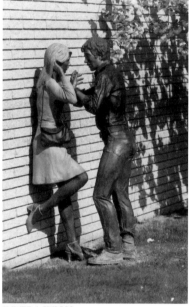

INTERACTION

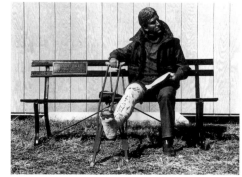

APRES SKI

COLLECTIONS

UNITED STATES

California
American Savings and Loan, Stockton
Birchbrook Center Venture, Brea
Cambio Investments Inc., Fullerton
City of Sunnyvale
Equitable Life Insurance Co., San Francisco
Gus Enterprises, Bakersfield
Syntex, Palo Alto

Colorado
Public Employees Retirement Association, Denver

Connecticut
Collins Development, Stamford

Florida
Harbor Branch Foundation, Fort Pierce
Lincoln Property Company, Tampa

Georgia
The Crow-Terwilliger Company, Atlanta
Rosen Associates, East Cobb
Thermo Materials Group, Atlanta

Illinois
The Arthur Anderson Company, St. Charles
General Automation Company, Skokie
The Lenox House Hotel, Chicago
Safety Kleen Corporation, Elgin
Tyndale House Publishing, Wheaton

Indiana
P. R. Duke Associates, Indianapolis
Lincoln National Corporation, Fort Wayne

Kansas
Nichols Plaza, Kansas City

Kentucky
The Webb Companies, Lexington

Louisiana
Lincoln Property Company, New Orleans
West Jefferson General Hospital, Marrero

Maryland
City of Baltimore

Michigan
City of Detroit

Missouri
The St. Louis Centre, St. Louis

Nevada
American Nevada Corporation, Henderson

New Jersey
Hamilton Township
The Morris Museum, Morristown
Princeton University, Princeton
Ramapo College, Mahwah
The State of New Jersey
Trinity Church, Princeton

New York
Chemical Bank, New York City
1839 Central Plaza Associates, Colonie
Gould Limited Partners, Great Neck
Hofstra University, Hempstead
Leaders Magazine, New York City
Manhattan East Suite Hotels, New York City
Rich Products Corporation, Buffalo
The Robert Martin Company, White Plains

North Carolina
Allentown Realty and Insurance, Durham
Faison Associates, Charlotte
Hilton Head Institute for the Arts, Hilton Head
H. S. Lichten Developer, Raleigh
North Carolina State University, Raleigh
Sea Pines Academy, Hilton Head

Ohio
T. J. Evans Foundation, Newark
Trane Corporation, Cincinnati

Oklahoma
Helmerich and Payne, Tulsa

Oregon
City of Portland
Washington County Times, Forest Grove

Pennsylvania
Lancaster Newspaper Company, Lancaster
Presbyterian Hospital, University of Pennsylvania, Philadelphia

South Carolina
Equity Management, Columbia

Tennessee
Property Company of America, Nashville

Texas
Trammell Crow Company, Dallas
Lincoln Property Company, Arlington
Lomas and Nettleton, Dallas
Rust Properties Company, Austin

Virginia
Anden Group, Sterling
Great American Homes, Newport News
Property Company of America, Vienna
Westfield Realty, Rosslyn
William and Mary College, Williamsburg

BERMUDA
Ariel Sands Hotel and Club, Devonshire

CANADA
City of Calgary, Alberta
City of Edmonton, Alberta
Vancouver Museum, Vancouver
Westmount Life Associates, Montreal

WEST GERMANY
Haribo Corporation, Bonn
Private collection, Eltville
Private collection, Hanau

PUBLIC PLACEMENTS

UNITED STATES

California
American Savings and Loan, Stockton
Birchbrook Office Park, Brea
Cambio Investments, Memorial Quadrangle, Fullerton
Equitable Life Insurance, San Francisco
Fifth and Embarcadero, Oakland
Sheraton Valley Inn, Bakersfield
Sunnyvale Public Library, Sunnyvale
Syntex, Corporate Headquarters, Palo Alto

Colorado
Public Employees Retirement Association, Denver

Connecticut
Harbor Plaza, Greenwich
National Sports Museum, North Haven
Palmer Point, Stamford
Schooner Cove, Stamford
Yale University, Morse College, New Haven

Florida
Boca Raton Hotel and Beach Club, Boca Raton
Harbor Branch Foundation, Fort Pierce
The Lincoln Hotel, Tampa
Riverside Theater, Vero Beach

Georgia
Plaza Walk Shopping Center, Atlanta
Shallowford Falls Shopping Center, East Cobb
Wyndham Garden Hotel, Atlanta

Illinois
Arthur Anderson Professional Educational Center, St. Charles
General Automation Company, Corporate Headquarters, Skokie
The Lenox House Hotel, Chicago
Safety Kleen Corporation, Corporate Headquarters, Elgin
Tyndale House Publishing, Corporate Headquarters, Wheaton

Indiana
Lincoln National Corporation, Fort Wayne
The Radisson Hotel, Indianapolis

Kansas
Nichols Plaza, Kansas City

Kentucky
Festival Market Place, Lexington

Louisiana
Energy Center, New Orleans
West Jefferson General Hospital, Marrero

Maryland
Baltimore Convention Center, Baltimore

Michigan
Grand Circus Station, Detroit
Sunset Hills Cemetery, Flint

Missouri
The St. Louis Centre, St. Louis

Nevada
Green Valley, Henderson

New Jersey
Eggarts Crossing, Ewing Township
Morris Museum, Morristown
Nathan's Theaters, Cinema Plaza, Flemington
Norman Bleshman School, Paramus
Palmer Square, Princeton
Princeton Borough Hall, Princeton
Princeton Community Park, Greenbrier Road, Princeton
Princeton University Campus, Princeton
Ramapo College, Mahwah
Richard J. Hughes Justice Complex, Trenton
Trinity Church, Princeton
Veterans' Park, Hamilton Township

New York
Chemical Bank World Headquarters, New York City
Dumont Plaza Hotel, New York City
Exxon Park, Rockefeller Center, New York City
Hofstra University, Memorial Quadrangle, Hempstead
Hofstra University, University Club, Hempstead
Leaders Magazine, World Headquarters, New York City

Liberty Park, New York City

Majestic Midtown Corporation, New York City

Majestic Neck Corporation, Great Neck

Rich Products Corporation, Corporate Headquarters, Buffalo

Seward Johnson Park, Leaders Conference Center, Bath

The Westchester Financial Center, White Plains

The Whittler Plaza, Colonie

North Carolina

Equity Management, Corporate Headquartrers, Columbia

Hilton Head Institute for the Arts, Hilton Head

North Carolina State University, Main Campus, Raleigh

Sea Pines Academy, Hilton Head

University Tower Office Building, Durham

Waverly Place, Cary

Ohio

City Square, Newark

Ohio State University, Main Campus, Newark

Trane Corporation, Corporate Headquarters, Cincinnati

Oklahoma

Helmerich and Payne, Tulsa

Oregon

Pioneer Courthouse Square, Portland

Washington Company Times Building, City Square, Forest Grove

Pennsylvania

Lancaster Newspaper Company, Corporate Headquarters, Lancaster

Law Offices of Joseph D. Shein, Philadelphia

Presbyterian Hospital, University of Pennsylvania, Philadelphia

South Carolina

Equity Management, Corporate Headquarters, Columbia

Tennessee

American Center I, Nashville

Texas

Bryan Tower, Dallas

Concorde Bank, Dallas

Diamond Shamrock Tower, Dallas

Lincoln Square, Arlington

Loewes Anatole Hotel, Dallas

Lomas and Nettleton, Viceroy Campus, Dallas

LTV Center, Dallas

Preston Park Village, Plano

Virginia

American Center, Tysons Corner, Vienna

Great American Homes, Corporate Headquarters, Newport News

James Center, Richmond

Loudon Country Day School, Leesburg

Parc City Centre, Sterling

USA Today Building, Rosslyn

Valley View Mall, Roanoke

William and Mary College, Williamsburg

Washington, D. C.

Capital Children's Museum

Eastern Market

Georgetown Park

Haines Point Park

Wisconsin

Red Carpet Hotel, Milwaukee

BERMUDA

Ariel Sands Hotel and Club, Devonshire

CANADA

Centennial Park, Calgary, Alberta

Churchill Park, Edmonton , Alberta

City Hall, Calgary, Alberta

Queen Elizabeth Park, Vancouver, British Columbia

Stanley Park, Vancouver, British Columbia

Westmount Life Building, Montreal

WEST GERMANY

Haribo Corporation, Corporate Headquarters, Bonn

SOLO EXHIBITIONS
Partial listing

Boca Raton Hotel and Beach Club, Boca Raton, Fla., 1981–1987

Middlesex Hospital, New Brunswick, N. J., 1982

Yale-New Haven Parklands, New Haven, Conn., 1982, 1983

Inn on the Park, Houston, Texas, 1982, 1983, 1984, 1985

American Institute of Architects Conference, New Orleans, La., 1983

Citicorp Center, New York, N. Y., 1983

Four Seasons Hotel, Vancouver, B. C., Canada, 1983

Four Seasons Olympic, Seattle, Wash., 1983

Morvin Estate, Princeton, N. J., 1983

Nippon Club, New York, N. Y. 1983

Four Seasons Hotel, Washington, D. C., 1983, 1984

Georgetown Park, Washington, D. C., 1983–1987

Riverside Theater, Vero Beach, Fla., 1983–1987

American Institute of Architects Conference, Phoenix, Ariz., 1984

High Museum, Atlanta, Ga., 1984

San Mateo Bay Center, San Mateo, Cal., 1984

Tabor Center, Denver, Colo., 1984

Keystone at the Crossing, Indianapolis, Ind., 1984, 1985, 1986

Galleria Specialty Mall, Atlanta, Ga., 1984, 1985, 1986, 1987

Mandalay Four Seasons Hotel, Irving, Texas, 1984, 1985, 1986, 1987

Philadelphia Four Seasons, Philadelphia, Pa., 1984, 1985, 1986, 1987

Four Seasons Hotel, San Antonio, Texas, 1984, 1985, 1987

Green Valley, Henderson, Nev., 1984–1987

American Center, Austin, Texas, 1985

American Institute of Architects, San Francisco, Cal., 1985

Hofstra University, Hempstead, N. Y., 1985

Independence Center, Charlotte, N. C., 1985

Jacksonville Art Museum, Jacksonville, Fla., 1985

John F. Kennedy International Airport, New York, N. Y., 1985

Port Authority Terminal, New York, N. Y., 1985

Rancho La Costa at Carlsbad, Carlsbad, Cal., 1985

Skyline View Tennis Club, Reno, Nev., 1985

Slifer Square, Vail, Col., 1985

Williams Center, Tulsa, Okl., 1985

World Trade Center, New York, N. Y., 1985

Air Canada Pavilion, Expo '86, Vancouver, B. C., Canada, 1986

American Center 1, Nashville, Tenn., 1986

American Institute of Architects Conference, San Antonio, Texas, 1986

Columbia Mall, Columbia, Mo., 1986

Westin La Paloma, Tucson, Ariz., 1986

Gerald R. Ford Amphitheater, Vail, Colorado, 1987

Miami International Design Center, Miami, Fla, 1987

Washington Harbour, Washington, D. C., 1987

GROUP EXHIBITIONS
Partial listing

11th International Sculpture Conference, Washington, D. C., 1980

Mile of Sculpture Exhibition, Chicago, Ill., 1982

1982 Worlds Fair Sculpture Park, Knoxville, Tenn., 1982

Pavilion Gallery, Mt. Holly, N. J., 1982

Sculpture '82 Exhibition, Cheltenham, Pa., 1982

State University of New York, Potsdam, N. Y. 1982

12th International Sculpture Conference, Oakland, Cal., 1982

"Bronze at Washington Square," Washington, D. C., 1983

California College of Arts and Crafts, Oakland, Cal., 1983

Wave Hill Sculpture Park, Brooklyn, N. Y., 1983

Nabisco Corporation, East Hanover, N. J., 1981, 1984

The New Jersey State Museum, Trenton, N. J., 1984

Smithsonian Institution Traveling Exhibition Services, Three-Year Exhibit, 1984–1987

Warner Communications, New York, N. Y., 1984

Millhill Park, Trenton, N. J., 1985

Cheekwood Fine Arts Center and Botanical Gardens, Nashville, Tenn., 1986

J. P. Speed Art Museum, Louisville, Ky., 1986

"Figures," Washington Square, Washington, D. C., 1987

ARCO Sculpture Garden, The American Film Institute, Los Angeles, Cal., 1987